SECOND EDITION

THE PHOTOGRAPHER'S GUIDE TO MARKETING AND SELF-PROMOTION

Maria Piscopo

ALLWORTH PRESS, NEW YORK

Published by Allworth Press, an imprint of
Allworth Communications, Inc.
10 East 23rd Street, New York, NY 10010

Book design by Douglas Design Associates, New York

ISBN: 1-880559-24-2

Library of Congress Catalog Card Number: 95-75285

THE PHOTOGRAPHER'S GUIDE TO MARKETING AND SELF-PROMOTION

Contents

•
•
•
•
•
•
•
•
•

Introduction

•
•
•
•
•
•
•
•
•
•

Many of you have already read the first edition of *The Photographer's Guide to Marketing and Self-Promotion*. When I first considered writing the book, it was a gentler, kinder world. Not that I'm complaining, but everything about marketing photography services has changed. From the type of clients, to working with reps, to the technology of the marketing process—it's a different world. If you are just starting out, congratulations, and read chapter 18 first. You have the advantage because you are not thinking of the way things used to be.

If, like so many of us, you have been in the business awhile, stop waiting for things to "get back to normal." Many of you that have been in business for ten, twenty years have this feeling that "they" changed all the rules, and nobody called to tell you! Well, there is a new normal, and all new rules and we will examine them, along with samples and quotes from various photographers, in this book.

From an historical perspective, you learn in photography school about producing images—maybe even with the new digital technology. But with few exceptions, schools don't address the business aspects of "selling yourself." Even professionals that have been in business for many years have been caught unprepared by the new economy and marketplace. The thousands of photographers that began and ran their businesses by referral and word-of-mouth are being forced to reevaluate their strategy.

To bring this book and you into the "digital nineties," you need to understand that the new digital technology can accomplish two things. One, it can provide you with additional tools for producing photography (*digital capture*). Two, it can provide you with additional services to offer clients (*digital imaging*).

You are not in the business of marketing or promoting digital photography by itself. Clients will not call you and ask for a digital photograph. What they will do, is ask if you can capture or manipulate photographs digitally. What clients are interested in, is your style and ability to produce images.

Therefore, your marketing and promotional tools don't change with your ability to do digital capture or imaging. Advertising, direct mail, public relations, and selling will still be your primary marketing tools as new technology evolves.

Teaching the Business of Photography

I first became involved with teaching the business of photography as a faculty advisor at Orange Coast College in Costa Mesa, California. It had one of the first photography departments to devote a full semester of class strictly to business. The class was only about the buying and selling of photography services. Though business classes can be taken in the business department of any college (and they should be!), there are many issues particular to the photography industry that make a class like this necessary in today's new marketplace. This class led to writing my first book, teaching seminars, offering private marketing plan consultations, and this most recent book. In addition, Turner Video Communications has produced a series of videotapes showing and describing much of the material from both my classes and seminars dealing with today's new clients.

Whether you plan to pursue freelance assignments on the side, full time self-employment, or if you have been in business for twenty years, you'll find this book has tips and techniques that you can use. My objective is two fold: One, is to share the information on the new marketplace and how to find and deal with its clients. Two, is to raise the level of business practices and professionalism of the photographers all of our clients deal with. Clients will treat photographers as they are trained to, and that level of training must be raised to deal with the tremendous number of variables in today's business environment.

As a rep for Stan Sholik Photography for the last fifteen years, I want to especially thank Stan for being one of the true leaders in the photography industry for the promotion of better business practices. He has always been a wonderful role model (and reality check) for me, when dealing with a tough business issue.

Business Has Changed

The best illustration of how the business has changed, is in the strategy for obtaining photo assignments. Twenty, fifteen, ten, even five years ago, you could go out with a portfolio and a business card and get work. Now, you need many different levels of exposure utilizing tools like advertising, direct mail, publicity, and selling. These tools allow you to reach clients, help them understand what you can do for them, and remind them of it until they have an assignment for you!

Not that portfolio presentations have become extinct, a good face-to-face meeting with a client is still the best way to get work. It's getting their attention that has become the true challenge of the marketing and promotion of photography services. As in my first book, you will find money alone is not the key to self-promotion. "Plan the work, then work the plan" will be the bottom line, not how much money you have.

Whether you have five-thousand or fifty-thousand dollars to spend on self-promotion, the rules and techniques are the same. At the high end, you are going after bigger clients and better budgets. At the low end, you could be just starting out, going after low-budget clients, or trying out a new style on your current clients. Whatever the plan, strategy comes first. What are you selling? Who buys it? How can you best reach these clients? Decide on these questions first, then you'll be able to determine your budget.

The Key to Self Promotion

The key to self-promotion (and maybe even to being successful at anything you try) is to incorporate it into your day-to-day life. The worst time to start a marketing plan is when you have the time for it; then it's too late. You have time because you have no work! Study chapter 19 very carefully. Everything you plan must be cross-referenced to your daily calendar. Your job of self-promotion must be an everyday event, not something you do whenever there's no work to shoot.

Probably the other biggest problem to overcome is the tendency to do "shotgun" marketing—a mailing here, an ad there. The plan you write when you are finished reading and using the material from this book will help you avoid this problem. With a written plan, you can always ask "Does this fit into my strategy?" whenever an opportunity to promote yourself comes along. From getting a rep to running an ad, the plan will guide you much as a map does. Think about it. Given two photographers who have to reach an unfamiliar and unknown destination on their own, if one has a map showing how to get from here to there, and the other is told "Go west, you'll get there

eventually," who gets there first? The map is the key. The marketing plan you write is the key to unlock your success.

A Preview of What You'll Learn

The remainder of this introduction will preview the chapters that follow. As the book unfolds, we'll look at all of the tools available to you as a commercial photographer that will help you find clients and get jobs.

Before continuing, however, I'd like to answer one question I always get asked. That question is, "Yes, but will the ideas you recommend work for me?" The only guarantee I can give you is if you don't do anything in the way of promotion, you won't be as successful as you could be. Ideas don't work for you. You work for you!

The first thing to understand is that promotion is like any building. It is made up of different parts that work together in order to create a strong structure. Each part of the structure complements the other, and none work as effectively on their own as they do together. Marketing works the same way. Marketing plans include advertising, direct marketing, public relations, and selling. All of the elements must work together and are discussed in detail.

The teaching portion of the book begins with chapter 1, the business side of self-promotion. Because today's economy demands more business skills, time and stress management, skills to build confidence, and goal-setting are also included. Mastering these skills is essential before you begin any self promotion.

Chapters 2 through 6 deal with several different ways to promote a photography business. All methods are proven. All should be included in your marketing plan. The initial discussion is devoted to advertising. Who is your target market? How do you know if anyone has seen your ad? How much should you invest? Because advertising is by far the most costly promotional tool, we will look at both the objectives, and criteria for designing cost-effective ads.

Direct mail is another important promotional tool. In chapter 3 you'll learn how direct marketing by mail compares with display advertising, how to put together a successful campaign, and you'll see some samples of successful direct mail pieces. Tips and techniques for increasing response are also discussed.

Not all promotion is done by ads or mail. Chapter 4 looks at basic promo packages, including primary and secondary promotional material, capabilities brochures, and informational promotions. Comments are also included on the use of non-traditional promotions.

Publicity is the most overlooked promotional tool and the least expensive! In chapter 5, find out how to get your work published where your buyers will see it at no cost to you. Learn how and when to write a press release for your target media. In addition, you will learn how entering awards and planning events will increase success of your public relations plan.

Perhaps the most overlooked promotional opportunity is association marketing. In chapter 6 we show you how to use associations to meet "centers of influence," people that can boost your career. A low-cost association marketing campaign can increase the effectiveness of your advertising, direct mail, public relations and selling.

Chapter 7 is about selling and teaches you what your clients need to know before they hire you. Techniques like "relationship" and "needs" selling are presented, and steps you'll need to take to get portfolio presentations are discussed. Follow-up on how to get jobs after your portfolio presentation is included.

Working in major metropolitan areas presents special challenges. If you live in New York, Chicago, or Los Angeles, or want to sell your photography services to clients in major metropolitan markets like these, chapter 8 will give you specific tips you need to be successful.

Where do you start looking for clients? In chapter 9 you'll learn how to target markets and focus on the areas you want to get work in. Identifying clients alone isn't enough. Chapter 10 shows you how to successfully approach prospective clients by working within your marketing structure. If your promotion plan is fully in place, you will not be making "cold" calls because your prospective client will have already seen your ad, or received your direct mail piece.

In chapter 11 you'll learn how to plan and present your portfolio. A polished portfolio will help you get the work you want to do. Unfortunately, it's no longer enough to get that first job and assume you have a client-for-life. Chapter 12 will teach you how to develop a mutually beneficial working relationship that will keep clients coming back.

Self-promotion always leads to the inevitable question, "What do you charge?" Why is that the wrong question to ask? How can you avoid pricing your work too low? Chapter 13 teaches simple negotiating techniques to make pricing your work easier and more efficient. In addition, you'll learn how to package your cost proposal to make sure you get the job.

Like any other business, there will be ethical considerations that confront us on a daily basis. How you handle ethi-

cal questions can either cement, or virtually guarantee that a client relationship will end. Chapter 14 will teach you how to identify potentially dangerous ethical situations. The Joint Ethics Committee Code of Fair Practice is included in this chapter in order to clarify acceptable and proper conduct.

Finding a representative or agent may or may not be a cost-effective marketing solution. Chapter 15 will help you decide if you are ready for a photographer's representative. It will also teach you what representatives look for in photographers, the advantages and disadvantages of having a representative, changes in the representative/photographer relationship, and how to start the search.

In chapter 16, we'll examine a new career in photography, the marketing coordinator. This employee can be just the person you are looking for to implement the marketing plan you are about to write. Included is a job description for a marketing coordinator, what to pay, and how to find one.

Chapter 17 illustrates the important contributions computers can make. On the business side, they are invaluable for bookkeeping, marketing/promotion, and project management. On the creative side, digital imaging services like retouching or photo composition can increase both profits and creative control.

Chapter 18 shows you how to get your business started. Or, if you are already in business, this chapter serves as a valuable reality check to help you keep your business on track.

If you haven't already guessed, pulling all this information together so that it can be implemented in a cost-efficient manner requires a written marketing plan. A typical outline of a marketing plan is presented in chapter 19. It is not "your" marketing plan. But, it does provide you with a framework for you take your ideas and plan what you will be selling, who you will be selling to, and how you will get the work.

Writing your plan, unfortunately, isn't enough. Chapter 20 will teach you scheduling techniques to insure that you keep your self-promotion plan on track. Developing a referral network to get assignments, and a discussion of self-assignments to help you build the portfolio you'll need to successfully promote your business are also included in this chapter. Finally, if you are having trouble with any of the terms used in this book, I've included a glossary. Please refer to it whenever you need to.

One last hint...adapt, not adopt! As I've said before, that is the key to success, and what I hope you will keep in mind as you read this book.

The Business Side of Self-Promotion

No matter what your area of photography, you have been dealing with a permanent change in the photography industry. Simply put, you can no longer be just a photographer. The future belongs to the owners of photography businesses. If you have recently said to yourself, "All I really want to do is be a photographer," you need to reexamine your objectives for being here. No matter what plan for marketing and self-promotion you get from this book, everyone has to deal with the business side. Here are four factors, on the business side, that you need to have control over before you can be successful with the tools and techniques of promotion.

Goal Getting

Setting goals is too passive an exercise for the success of your marketing plan. Owners of photography businesses need to plan for success and not wait for it to happen. You need to get goals, not just set them. The key to successful goal achievement is to write it down. Your subconscious simply does not recognize an unwritten goal. Putting your desires onto paper (or floppy disk) creates an unrestricted flow of energy and dedication to achieving those goals. Yes, that may sound a little strange, but what could you possibly lose by giving it a try? Nothing! You can only win. Use the goal-getting outline below for your business and marketing goals.

State Your Objectives

These are the things you want to achieve. Write down all of them—big ones and little ones. Keep adding to this list even though you won't take action on everything at once, it's best to have a clear picture of what you want from your business. Be sure to use action statements such as, "I want to sell $150,000 worth of photography services this year," and not vague statements such as, "I want to be rich."

Actions Required

Decide which of the above objectives you want to achieve right now. Pull them out of the above list and add the activities needed for their accomplishment. Be sure to be specific and break down tasks into "bite sized" pieces. For example, one of your goals might be to hire a marketing coordinator. Break that goal down into actions you can take, for example: write job description, get newspaper classified ad rate information, write ad, etc. This should be a step by step outline of tactics describing how you will handle your current goals.

Assign Resources

Next, add to each of the above tasks information regarding the time and/or money they will require. You already have a marketing budget for the business and some of that can be applied towards specific goals.

Schedule Everything

Finally, take your daily calendar and schedule all of the items listed in step two. Then, accomplishing your business goals becomes a daily activity and not something you have to find the time to think about. Just do it!

Time Finding

You know that any activity expands to fill the time given to it. So, unless otherwise managed, your day will fill up with things to do other than business. Because of this, you want to know where you will find the time to do everything you need to do (managing the business), want to do (goal getting), and have to do (photo assignments). The time is there. All you have to do is uncover it. Time can be buried in a number of different ways. Any of these sound familiar? *It's fun:* you give priority to tasks that are agreeable and then have no time left to do the less enjoyable but maybe very necessary chores because

your day is "full." *It's easy:* a different side of the same problem. By doing all the easy things first, you bury the time for the bigger and harder jobs because you are waiting to "find" the time. *It's here:* doing whatever is in front of you without regard to priority or level of importance, so that half the day is gone and you don't know where it went. Now that you are aware of how you hide the time, let's look at how to uncover it.

Use Your Calendar to Manage Time

Take your marketing plan and your goal-getting plan along with your daily calendar, and transfer every item onto the calendar. Be sure each item is specific and manageable (as in "bite sized" tasks), and be careful to allow enough time. Do you know how long it takes to pay bills, process the daily mail, write a press release? You'll quickly find out. Don't forget vacations and holidays!

Handle Work Immediately or Schedule It

As things come to your attention during the day you will handle them immediately and completely, or you will schedule the handling of them. For example, the Jones family calls you to request a family portrait and they want "something different" for an outdoor setting. Rather than dropping what you are doing at that moment to scout the location, use your calendar to find a more appropriate time to deal with this request. Everything goes on the calendar. No more lists of things to do!

Create a Tickler File

You'll need an important time-finding tool to work with your calendar. Put together a file of thirty-one folders numbered one through thirty-one. This is called a tickler file. Though there are computer programs (see chapter 17) to track the task, there always seems to be some piece of paper to keep track of! This way, as each paper crosses your desk, you have a place to put it. In the above example, you find some time on July 30 for the scouting, you write "Jones location" on your calendar for July 30 and put all the information pertaining to this in the folder numbered "30." No more piles of paper! The key to this method is to handle everything you touch only once. Then, deal with it immediately or schedule it. This will not only help you find more time but will do two other things that are important to a photography business: One, instead of waiting to find the time for marketing and management (you never will), they simply

become daily chores. Two, instead of getting depressed when you have a blank calendar, you will always have a task to work on that will help you move toward business success.

Confidence

If you study very successful business people, the one thing you will find that they all have in common is a very strong, calm sense of confidence. This confidence is made, not born. It comes from testing yourself and winning the tests. You are often called on to demonstrate your photographic creativity and technical ability. In addition, you need to prove your professional and business skills. The most important thing to know is that you must not wait to feel confident to act confident. You will wait forever! No, it turns out that your feelings follow your behavior. In other words, acting confident will eventually bring the feeling of confidence to you. Don't wait to overcome doubt and fear before facing any professional challenge. Accept that they are part of the process of testing and winning. Anxiety and hesitancy may feel like negative feelings, but you have to look at them as indicators that you are doing something you haven't practiced. For example, the first time you quote a really big job or tell a client they can't get the day they want, you will feel some fear and anxiety. Don't worry! You are experiencing a perfectly normal reaction any business owner will feel when being assertive. After all, you only have three choices for a business attitude and you always make a choice of one, whether you are conscious of it or not. An aggressive attitude means you get what you want without care or concern for the other party. A non-assertive attitude means you give people whatever they want without care or regard for the cost to you (a common problem in quoting photography jobs). Assertion is simply a state where you get what you need and the client gets what they want. Being aggressive could drive your clients away. Being non-assertive could put you out of business! Acting assertive may cause you some short term discomfort, but will ensure you long term satisfaction and profitability. The trick, of course, is to learn to accept the fear without waiting for it to go away and to go on to do the work at hand. The most common technique for this is called *visualization*. You must see yourself accepting the challenge, mapping a strategy to meet it and then successfully accomplishing the task at hand. No matter what the situation, this technique works to create success and the feeling of self-confidence that follows!

Dealing With Stress

Most stress in a photography business comes from trying to balance conflicting needs. You need to be business-like, and you want to be creative. You need to dedicate yourself to your work, and you want to spend time with your family. Sound familiar? You could probably write an endless list of personally and professionally stressful situations. The important thing is to accept that this stress is normal. Distress, such as family illness or natural disasters, is not the norm and can't be managed like stress can be. If you have determined that you are dealing with stress and not distress, try these simple rules.

Stop Trying to be Caught Up

You'll never be caught up, so stop trying. There will always be a never-ending succession of business and marketing tasks as well as your photography to do. Stop waiting for the in-basket to be empty. Stop anticipating feeling "caught up" with your work.

You Can't Control Other People's Feelings

You'll never make everyone happy. There will always be a photography client that will want you to feel or behave differently (especially with pricing). Stop expecting people around you to always approve of you or be happy with you. You can only do your very best to please your clients and run a profitable business. You can't control other people's feelings about you.

Worry Produces Stress

Worry is a great producer of stress. Have pen and paper handy so that you can write down any particular worry. Put it aside to be considered later (this technique is also known as "sleep on it"). Often, the worry will resolve itself or no longer be so overwhelming. So, get it off your chest. Mark Victor Hansen, a motivational speaker and teacher in Newport Beach, California, calls this type of stress "stewing without doing." It is very non-productive. Stop it!

Learn the Art of Saying No

Learn to say "no." Often, stress is created because you say "yes" when all logic and common sense tells you to say "no." Pricing a photography job is a perfect example. A client makes an assignment or pricing request and you know that an unqualified "yes" will cause great stress (and reduced profits). Try one

of these three options, "No, but here's another option to look at"; or "yes, and this is what that change will cost"; or, simply put, "let me get back to you!" In each case, you have presented further considerations that will reduce the stress of saying "yes" when you mean "no."

Advertising as a Marketing Tool

In chapter 1 you learned about the business skills required to be successful. Before we look at the specific tools and techniques for marketing and self-promotion, let's take a minute and look at the overall picture. Marketing involves non-personal and personal techniques. Non-personal marketing includes advertising, direct mail, promo pieces, public relations, and packaging your cost proposals. They are non-personal because they promote your business without your physical presence.

Personal marketing includes networking, researching and approaching new clients, presenting your portfolio, and keeping clients coming back. They are personal because they must be done on a one-on-one, individual basis. Since advertising is one of the most common and visual forms of non-personal promotion, we will discuss it first.

Where and When To Advertise

Advertising is one of the largest areas of expense in your budget for self-promotion. Before buying your next ad, let's look at some of the factors for successful advertising.

Start with a profile of the client you are trying to reach with your advertising. Ask a select group of your clients (and potential clients) what publications and annual directories they receive. Then, ask them which they use on a regular basis.

Having them around doesn't necessarily mean your ad will be seen. When you visit clients' offices, make a note of the publications and source books you see on coffee tables and desks. To reach an even larger survey sample, mail a survey with a postage-paid response to your target audience.

The decision to advertise is most important when your client profile tells you that your pool of potential clients is so large that traditional direct mail and selling techniques will not reach all of them. Whether you are considering a business-card size ad in the local Chamber of Commerce magazine or a full-page display ad in a regional or national source book, you must feel confident that the blanketing effect of your ad will work. There are two approaches to deciding whether or not to use an ad campaign. One, you want to keep your name recognition at the very high level you have established (image advertising). Two, you want to sift through the clients reached by your ad and determine the ones interested in working with you (response advertising).

You know you are ready to consider advertising when your marketing message is very clear and focused. For a strong, visual style that is clear and distinct in its uniqueness, a source book ad (either regional or national) would be an option. For example, Michael Norton of Phoenix, Arizona was able to successfully reach out to the national advertising market with his strong western style marketing message advertised in a national source book (Fig. 1).

When you have a subject-specific message (i.e. food photography), considering an industry publication or local source book would be appropriate. It is very important to make a strong and immediate impression with one marketing message. When you have multiple specialties, you need to separate the ad campaigns.

Don't overlook the value of free listings. Every industry has reference books that will sell you display ad space and many offer free (or low cost) information listings.

Designing Your Advertising

Once you have decided that an ad campaign is an appropriate and effective method of reaching your audience, sit down with your art director or designer. Review the checklist below for factors to increase the effectiveness of your advertising.

Fig. 1

Design Your Ad to Solicit a Response

Decide on the goal. Unless you have a well-established name and marketing message or style to maintain with an "image" ad, be sure to design your ad for soliciting a response. After all, if you don't, then you are just showing pretty pictures and hoping a client decides your work applies to their needs. By creating an ad that compels clients to inquire, you have created the sifting device needed to filter a large pool of potential clients down to a few interested ones. For example, J.W. Burkey's advertisement (Fig. 2) in a national design magazine.

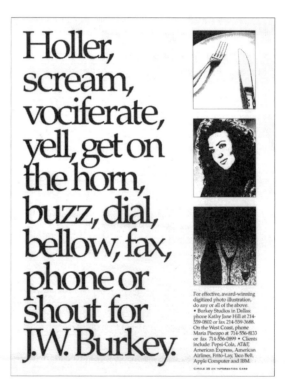

Fig. 2

Decide What Makes You Special

Determine what makes you or your photography special. It could be a style, cultural background, the location of your studio, or even the ad concept itself. For Stan Sholik (Fig. 3), advertising in one of the "boutique" specialty source books, *Rx Plus*, focusing on the play on words between his style (macro photography) and concept (no job too small) makes his ad stand out.

Fig. 3

Ad Frequency is All Important

Plan for the long term run of an ad. Your ad will need anywhere from six to sixteen exposures to your client before they will remember your message.

Use Testimonials to Add Credibility

Add credibility to the ad design with client testimonials, quotes, job references or association memberships. All any client knows for sure about you is that you found the money to pay for the ad!

Design Your Ads to Be Friendly

Include a sense of yourself and what you might be like to work with. Ads are an impersonal medium of self-promotion and need to be warmed up with an identity clients can relate to.

Advertise for the Long Run

Always think in terms of a campaign, not just an ad here or there. Advertising is a long-term commitment towards building an image in the minds of your potential clients.

Image Selection Criteria

The crucial part of any ad campaign will be the selection of images used to illustrate the ad's concept, design, and to make the marketing message statement. Here are some tips to review with your art director or designer.

Images Should be Subject Specific or Illustrate Personal Style

Most ads fall into two categories of image selection. A subject specific marketing message such as, "Call on us for your architectural photography needs," calls for all images to be in just the one subject area. Remember, you are advertising for the work you want to do more of (architectural) not the work you do (everything).

The second marketing message is your personal style or vision. These images will not be specific to any subject. In fact, it is important to show a variety of subjects as long as they are consistent in their style. Here, your message is: "Call on us when you want your images to look like this."

Make Use of Your Own Personal Style

Show the everyday subject in an extraordinary way in order to stimulate the client to call and inquire. Take any given subject—food, people, architecture—and shoot images with your own personal style. Your objective is to get your client to stop turning the pages of the publication or source book and study your images for more information. You want to create images for your ads that prompt clients to ask themselves, "How did they do that?"

Ads Show You Can Do a Certain Level of Work

Don't be too concerned when you discover a gap between what you show and what you do get as far as the type of image the client is looking for. Very often, your ad will move and inspire a client to call even when they do not have exactly that kind of work to give you. They simply want to work with a photographer that can do that level of work!

Above All Else, Be Creative

Finally, work with the most incredible creative team you can put together and think! Be creative about where and how you create an ad campaign. For example, Jim Piper of Portland, Oregon created a series of ads that opened more doors and generated more responses than anything he had tried previously (Fig.4). With a team of designers, he approached a Portland Harley Davidson dealer with an idea for an ad campaign. For a price consideration, they would get complete creative freedom to create an ad campaign to showcase the product and use as ads for themselves. The client jumped at the chance; the pieces were used for both newspaper ads and direct mail. Jim's costs came down considerably by "piggybacking" the client's campaign with his own and getting his best ad response ever!

Fig. 4

Direct Mail Marketing

In evaluating the effectiveness of your direct mail marketing campaign, you will apply some of the same criteria that you used for advertising. Both are forms of non-personal marketing. The advantage of direct mail marketing is that, unlike advertising, it is "hand delivered" to your client or prospective client. On the other hand, direct mail limits the audience you can reach by the limited number of pieces you can mail. The two work very well together in a continuous campaign where your ads expose a very large pool of clients to your marketing message, and your direct mail carries that message to a smaller pool of clients pulled from the larger group.

Design Criteria

Here is a ten-point checklist to review with your designer when creating your direct mail marketing.

Decide What Kind of Response You Want From Your Client

Unlike advertising, where you choose between reputation and inquiry responses, direct mail can be designed with any objective in mind. What is it, exactly, that you want people to do when they receive your mail? The possibilities have no limit and can range from a very passive or low-risk objective, such as "wait for our next mailing," to a very aggressive or high-risk

response, "call when you have a job!" There is no right or wrong, but you must be sure to match your response and risk factors. The lower the risk to your client, or the more passive they get to be in response to your mailing, the more people will respond. The higher the risk, or more work they have to do, the lower the response. Again, both work; you need to decide which one is right for your direct mail campaign.

One factor to help determine the type of response is the size of the mailing. With a very large quantity, you may want to use a high-risk response to get just your serious photography clients to respond. That is, people that are ready to talk to you about an assignment. If your mailing is very small and you want as many people as possible to inquire, then lower the risk! For example, Stan Sholik (Fig. 5) uses an "option" response mechanism of *call* (high risk) or *fax* (low risk) for more information. Arington Morgan Photography tells clients responding is low risk with their "no hassle" minibook (Fig. 6). J.W. Burkey's campaign asks directly for work (Fig. 7).

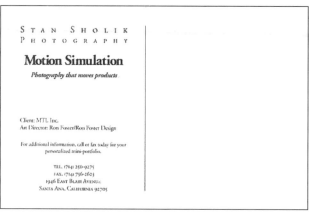

Fig. 5

Fig. 6 (front and back)

This image:
Art Directed by Russell Shuler
of Price McNabb Advertising
for Square D Corporation.
Photographed by Arington Hendley.

Arington · Morgan Photography
now offers a talented new shooter:

Lynda Green
Product & Portrait Photography

To get a portfolio or a no hassel minibook, call:
404 · 577 · 2300

Arington · Morgan Photography
404 · 577 · 2300
Atlanta

J.W. Burkey

We provide exciting bold images to designers and art directors
using photographs and computer image processing.
We'd love to work with you. Call us!

Burkey Studios
Phone (214) 746-6336
Fax (214) 746-6338

Represented on the West coast by:
Maria Piscopo
Phone (714) 556-8133
Fax (714) 556-0899

Fig. 7 (front and back)

Make an Offer They Can't Refuse.

Another method to increasing response rate to your mailings is to make an offer other than the traditional (medium to high risk), "Call for portfolio." A client would have to be really interested to accept that offer and respond. If you want more response, vary the risk and be creative! Peter Carter does successful direct mail "with an attitude," making offers appealing to the most creative and risk-taking clients on his list (Fig. 8).

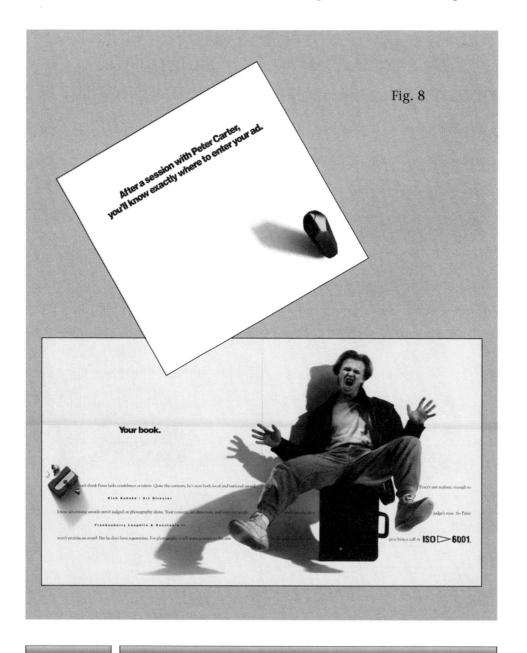

Fig. 8

Give Your Clients a Choice of Ways to Respond

Make it easy to respond by including the minimum range of response mechanisms directly on the printed pieces (so they stay when the envelope gets thrown away): firm name, your name (so they know who to ask for when they call!), full address with nine digit zip code, area code with phone number, and area code with fax number. Sometimes clients aren't interested enough to call, but would like more information. Give them the ability to do that and be sure you are using a dedicated fax phone number!

Clients Should Relate to Your Message

Clients should see themselves reflected in the copy you use in your mailings and be able to relate easily to your message. If the message is about you, it is more of an obstacle to the reader of your mail. For example, instead of writing, "I have a full service studio," turn it around and write, "You need a full service studio." In David Schmidt's award-winning direct mail campaign, the client clearly sees where they stand from his copy (Fig. 9): "Just what you needed"; "When you're bidding..." and "Please send us a set."

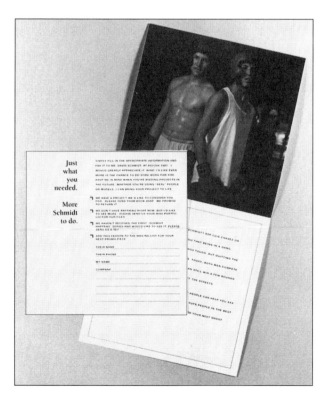

Fig. 9

Personalize Your Direct Mail

Include yourself in your direct mail marketing and make it the most personal form of non-personal marketing available to you! Consider any design technique that allows the client to get to know who you are: self-portrait, out takes from shoots, quotes from you, personal signature—be creative. Batista Moon Studio (Fig. 10) is in a small market in Northern California and faced the challenge of needing to focus and target in a traditionally "generalist" market. Barbara Moon and Fernando Batista decided, "Our visibility in the community was so high that we became like a fountain in the park—highly invisible. We needed to devise a marketing tool that was creative, low cost, and repeatable every month without getting old. The postcards give us just enough space to be creative without appearing too expensive a production. Once we had the format, we looked for a theme and decided that 'food' is a very organic and approachable subject in our market and has the highest billable rate for our area.

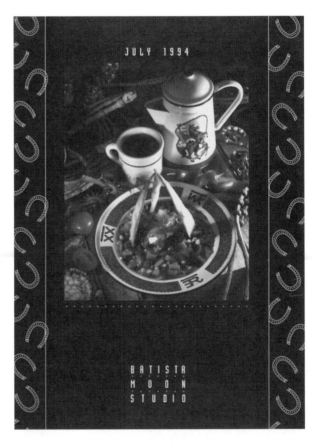

Fig. 10

"Each month, we pick a theme and find a chef in the area to work with. So far, no one has refused us—they love to get out of their kitchens and into our studio and do something new and creative! Their recipe is printed on the back along with the restaurant and all of the local merchant credits (they loan us the props). We look for recipes easy to prepare and with healthy ingredients. When we have twelve, we will think about doing a calendar. A portion of the proceeds from a calendar project would go to benefit a local food bank.

"Our dream is to do an entire book! Our secret is that direct mail promotion has to be more than using old solutions like printing just a promo piece for today's new problems. Our 'holistic' approach to direct mail with its efficient use of shrinking resources and connecting to the community is far more appropriate. Not only have we been getting calls for jobs, but calls thanking us for sending the cards. Both types of calls give us the opportunity to establish a relationship and discuss future projects."

Get the Client to Respond with a Deadline

Traditionally, giving a deadline to respond and receive your offer works to move the client to respond. Without one, there is more of a chance your mailing will go into a pile of "things to do" and never be seen again!

Make Your Direct Mail Piece Interactive

Ask for client's physical participation in your mailing with deign elements such as perforations, die cuts—anything that allows the client to take more action than simply opening your mail to them. Get them interested, intrigued, and involved enough to show all their friends in the office. John Connell's participation piece is a deliberately low-tech, interactive direct-mail promotion (Fig. 11) in a world where clients are being bombarded by high tech promotions. His "back to our roots" approach of a hands-on piece is not only a throwback in format, but gives clients a strong sense of his own "hands-on" approach to photography. Besides, it is a lot of fun to open!

Functional Direct Mail is More Likely to be Kept on File

Sometimes, you want your mailer to stay around the client's office. For this purpose, design a "keeper" of some kind that has both form and function. Think of this mailer as a mini-bill-

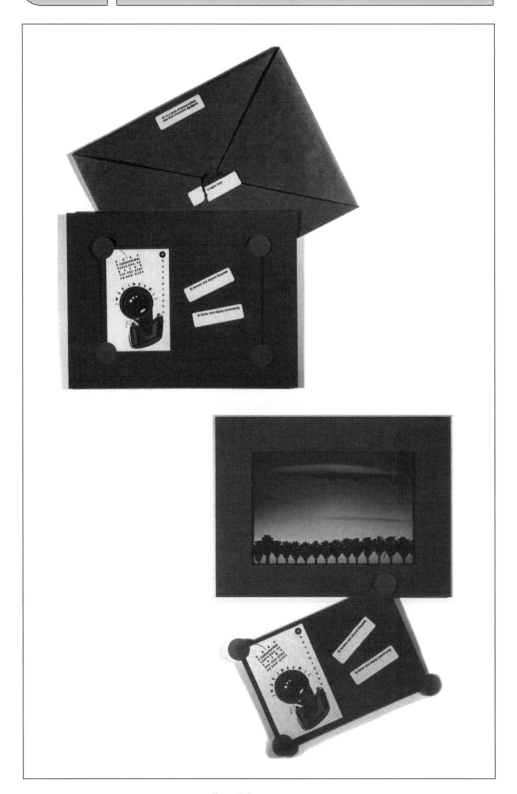

Fig. 11

board your client keeps in his office or on his desk. For example, Mark Culbertson's folder (Fig. 12), designed by Owens & Campbell in Mesa, Arizona, is almost impossible for clients to throw away. Everyone seems to remember the piece, and his name, probably due to the amount of perceived effort he put into it! Like most well-designed and produced direct mail promotions, he has received a two-percent front-end response on the return reply cards.

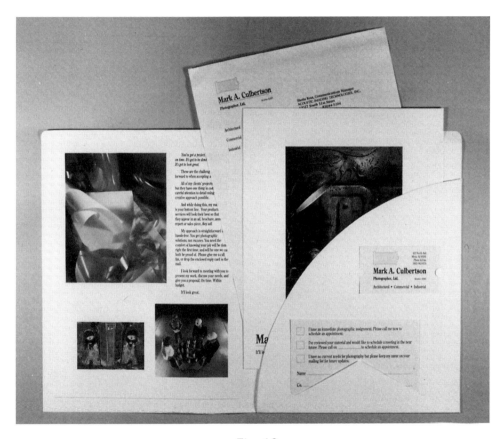

Fig. 12

Content Should be Relevant to Your Target Audience

Be sure your concept and content are relevant! Do your homework on the mailing list, and design for your targeted client profile. John Nordell has gone for the highly targeted (one hundred names) list which allows him (in fact requires him) to do a more expensive production that stands out from the crowd (Fig. 13). John says, "Though this is a more expensive

promotion, the first impression I make is one of quality. Though I'd love a designer to ask me to bid on a job rather than tell me my latest promo is 'Not just another piece of mail,' I know I am looking at the long term in building my business and have faith in the intangible ripple effect these direct mail promotions will bring."

Make It Believable

When your client looks over your mailer, they should feel they have learned something new or validated something they already know.

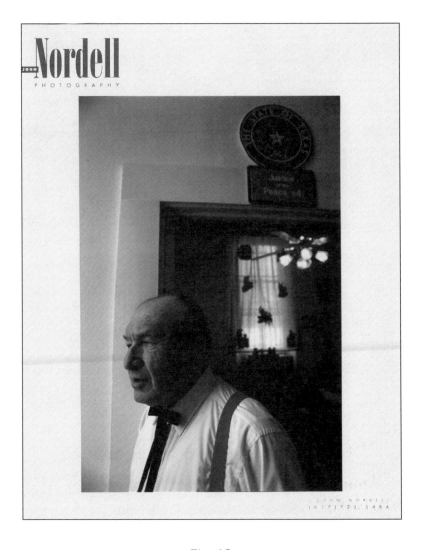

Fig. 13

Image Selection Criteria

Again, like in advertising, image selection is an important issue. Unlike advertising, there is a lot less pressure on the photographic image to carry the entire burden of the marketing message. You and your consultant and designer may decide to minimize or eliminate visuals and go with a clever all-copy mailer! For example, Ina Kramer's Art Director's Medical Survival Group did a wonderful series of two-color postcards (Fig. 14) to create name recognition.

Fig. 14

The main concern you have with mailings and image selection is to be careful of the exposure of too-broad an image assortment to your prospective clients. Your marketing message should be targeted to the work you want to do more of only! This is very narrow compared to the range of images your current clients are used to seeing. You may want to consider a separate, or additional, campaign for current clients to keep them with you. Since many of you have more than one marketing message, watch for crossover images for your direct mail campaigns. Crossover images allow you to use the same mailer for more than one kind of target market. For example, a portrait of a corporate executive may work in a direct mail campaign for both "people" photography and "annual report" photography.

Planning Ahead

When you plan your direct mail, design for campaigns of spaced repetition and frequency. Be sure to schedule design and production before you need them! Take your year's calendar and create a timeline working backward from the date you want the pieces to be mailed. When you want to reuse past mailers, plan on repackaging them in some way. The presentation of your piece alters the client's perception and allows you to use the same piece twice!

Probably the biggest mistake photographers can make in their direct mail marketing is the lack of consistency and quality of design and production. If you can't do it well, don't do it. This does not mean spending a lot of money! Start a budget for your mailings by getting printing estimates in advance of needing to spend the money. As soon as you have an approved design, find out how much the entire campaign will cost and start setting that money aside.

Promotion Pieces

Promotional materials come from everywhere and are generated from many sources. It is unlikely you can have too many promo pieces, but you can have the problem of many different promotion pieces without any plan. Plan the work (see chapter 19), then design your promotional material!

First you'll need "primary" promotional material. These are traditional, visual pieces used most often for sending ahead to get an appointment or for leaving behind after showing a portfolio. They can be inexpensively but nicely produced, such as the series Charles Shoffner (Fig. 15) uses for promotion. This traditional (and lower cost) production method of mounting prints to printed card stock works best when you have a very small target audience or are just starting out and have very little money! You don't have to spend a lot of money for promotion pieces to do them well!

With a larger audience, you may want to invest in printed materials such as the examples by John Nienhuis (Fig. 16) and Jeffrey Maloney (Fig. 17). These cost more money, but are less labor than the mounted prints. Design and quality of production is the key either way.

"Secondary" promotional materials can be added once you have some basic materials for "send ahead" and "leave behind" situations. Some of the secondary categories illustrated below include: miniportfolios, capabilities brochures, copy or information promos, newsletters, client-printed materials, and non-traditional or "specialty" advertising items.

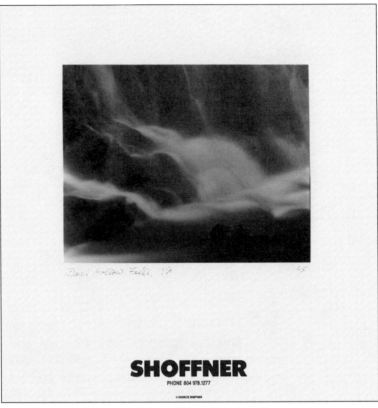

Fig. 15

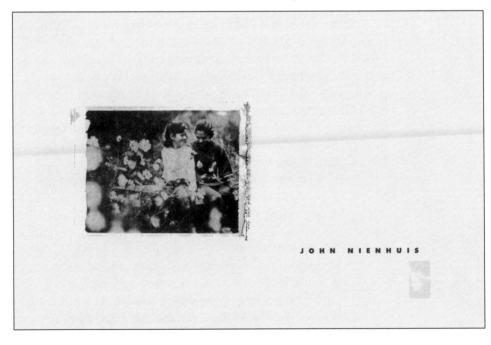

Fig. 16

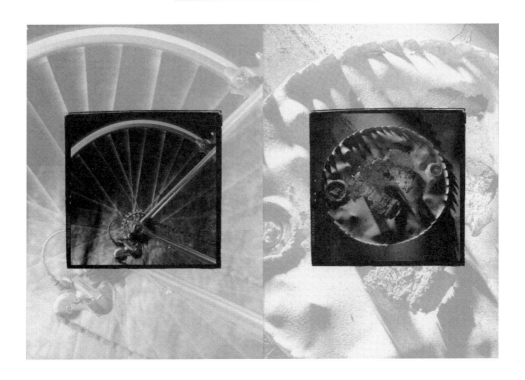

Fig. 17

The Miniportfolio Concept

Sylvia Bissonnette took the miniportfolio concept to its maximum with her "concept" piece (Fig. 18). The ultimate combination of concept, design, copy and photography comes together to produce a real "page turner" and a book clients call and ask for.

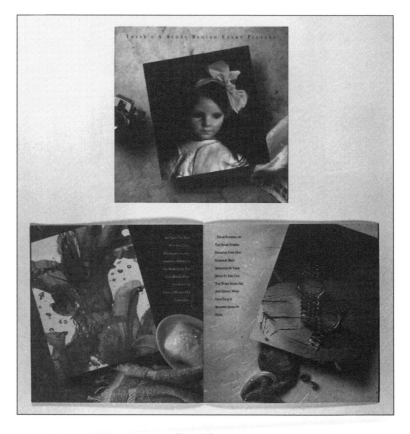

Fig. 18

Capabilities Brochures

The three examples of potential designs for a capabilities brochure presented below vary only depending on your final marketing plan. No one is right or wrong—all work for their intended purposes. Stan Sholik (Fig. 19) needed a one-page, one-color capabilities piece he could produce in-house for each of his studio's different capabilities. This includes all the basics (background, client testimonial, facilities inventory) and can be included with cost proposals, send ahead packages—or any other use!

MARIA

MARIA PISCOPO
2038 CALVERT
COSTA MESA, CA
92626
(714) 556-8133

ADVERTISING
PHOTOGRAPHY
STAN SHOLIK
STILL LIFE PHOTOGRAPHER
3200 square foot studio with 35mm through 8x10 camera formats

Represented by **Maria Piscopo (714) 556-8133**
FAX (714) 556-0899

Specialties: Food, medical/pharmaceutical products, computer and electronics. Large format close-up and macro photography.

Facilities: Stan's studio occupies 3,200 square feet, including a 30' cove. There's also a client conference area with a Lucygraf, copier, FAX and an extensive library of current source books and publications.
1946 East Blair Ave /Santa Ana, CA / (714) 250-9275. Off Deere, west of Redhill Ave., between Dyer and Alton.

Background: Born 1945, Boston, Massachusetts. Raised in Connecticut. Moved to California in 1968 after graduating college.

B.S. Physics, Carnegie Institute of Technology
M.A. English, Carnegie-Mellon University

Worked in aerospace industry for five years. In 1973 opened a commercial photography studio in Orange County.

Clients:

Alcon Laboratories	California Avocado Commission
Allergan Pharmaceuticals	Epson Computers
Baxter Edwards	McDonalds Corporation
C. Itoh Printers	Karl Storz

"I came back, deciding to work with Stan again, for several reasons. First, he seemed very confident he could do my work and he took extra time and care. I found Stan to be very sensitive to the smallest details and willing to meet my client's exacting needs."

"Second, we have great 'chemistry' and get along quite well together... that's important to me. I feel Stan understands my concerns and deadlines and is willing to be flexible because of our ongoing relationship."

Carl Seltzer, Designer

Fig. 19

The Purcell Team needed a more substantial design to illustrate their range of capabilities, yet, going for the long term and design flexibility, their four-color cover can be reused with a different interior spread (Fig. 20).

The Purcell Team

We cover the World

Stock Photography
Location Assignments
Image Enhancement
Photo Databases & CD-ROM
Brochure Design & Illustration
Photo Consultants
Slide and Multi-media Presentations
Photo Library Design
Scanning and duplication of slides

Carl & Ann Purcell
Phone: (703) 845-1104
Fax: (703) 845-1103

Fig. 20

Ira Mark Gostin uses the most flexible format for a capabilities brochure (Fig. 21). A cover folder (customized with a logo label) with inserts printed in advance and used as needed, depending on the client. This format is the most easily used and customized for individual client presentations.

This is especially important when you are specializing to become a generalist. Like most photographers in today's new marketplace, you may be faced with the need to sell yourself as a specialist to make the client feel safe enough to give you the work. However, very few photographers can survive in today's new marketplace with one specialty. To build a business, as a generalist, you simply need to market yourself in a number of different specialties with a variety of marketing messages. There are four marketing messages to choose from. You can specialize by photography type, industry, style, or subject.

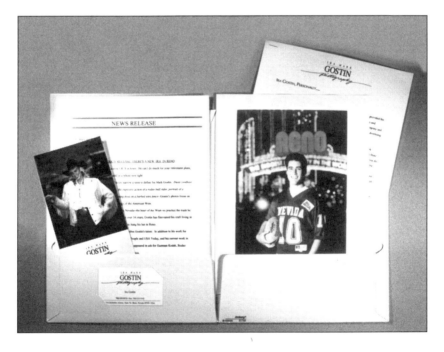

Fig. 21

Info-Only Promo Pieces

Copy-only or informational promotion materials are great supplements to current pieces. For example, Stan Sholik's studio "locator" map (Fig. 22) works very well with his same-sized capabilities brochure. Lauren Brill used moving her office as an excuse for a very inventive combination moving announcement and map to her new place (Fig. 23)!

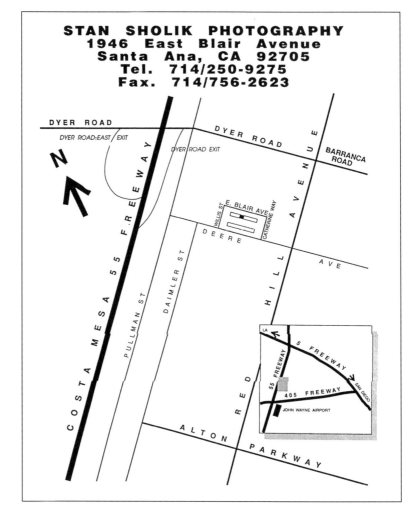

Fig. 22

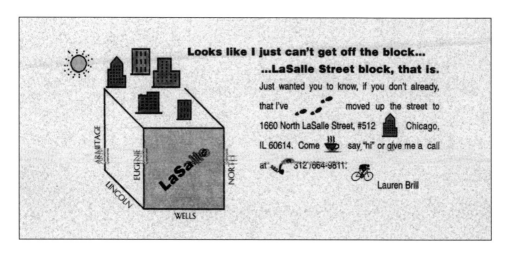

Fig. 23

Desktop Publishing Makes Newsletters Practical

Newsletters have always been a daunting prospect for photography promotion pieces. Now, with in-house desktop publishing software, they are growing more popular. They are still labor-intensive (someone has to come up with some interesting and newsletter-worthy copy!). M. J. Wickham, makes hers more interesting (Fig. 24) with the introduction of digital technology to produce the newsletters. The color images on the page come straight off her computer to a laser color copier. In the process of promoting this as her promo piece, M.J. is also letting her clients know about her expanded capabilities! Paul Epley is producing a newsletter based on project information. More aggressive in design, each newsletter will be mailed with a fax-response return reply (Fig. 25).

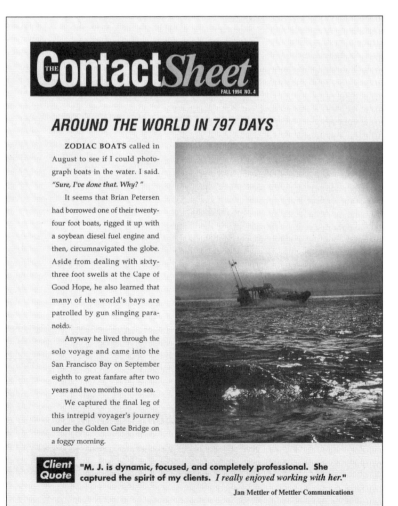

THE Contact *Sheet*

FALL 1994 NO. 4

AROUND THE WORLD IN 797 DAYS

ZODIAC BOATS called in August to see if I could photograph boats in the water. I said. *"Sure, I've done that. Why?"*

It seems that Brian Petersen had borrowed one of their twenty-four foot boats, rigged it up with a soybean diesel fuel engine and then, circumnavigated the globe. Aside from dealing with sixty-three foot swells at the Cape of Good Hope, he also learned that many of the world's bays are patrolled by gun slinging paranoids.

Anyway he lived through the solo voyage and came into the San Francisco Bay on September eighth to great fanfare after two years and two months out to sea.

We captured the final leg of this intrepid voyager's journey under the Golden Gate Bridge on a foggy morning.

Client Quote "M. J. is dynamic, focused, and completely professional. She captured the spirit of my clients. *I really enjoyed working with her.*"

Jan Mettler of Mettler Communications

Fig. 24 (cover)

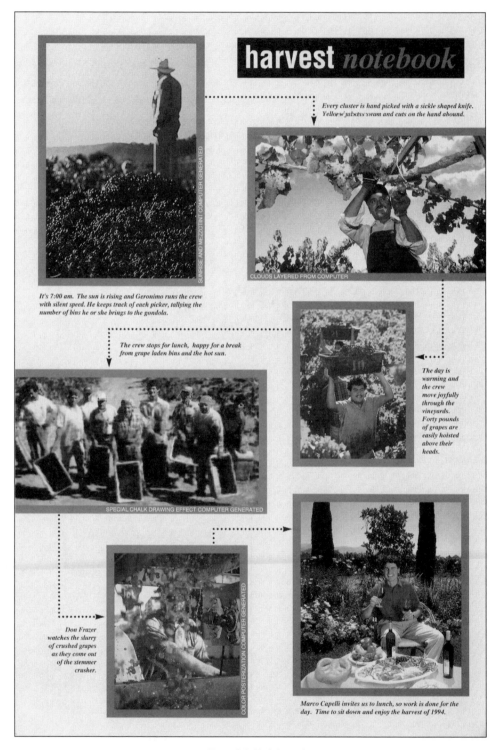

harvest *notebook*

Every cluster is hand picked with a sickle shaped knife. Yellow jackets swam and cuts on the hand abound.

SUNRISE AND MEZZOTINT COMPUTER GENERATED

CLOUDS LAYERED FROM COMPUTER

It's 7:00 am. The sun is rising and Geronimo runs the crew with silent speed. He keeps track of each picker, tallying the number of bins he or she brings to the gondola.

The crew stops for lunch, happy for a break from grape laden bins and the hot sun.

The day is warming and the crew move joyfully through the vineyards. Forty pounds of grapes are easily hoisted above their heads.

SPECIAL CHALK DRAWING EFFECT COMPUTER GENERATED

COLOR POSTERIZATION COMPUTER GENERATED

Don Frazer watches the slurry of crushed grapes as they come out of the stemmer crusher.

Marco Capelli invites us to lunch, so work is done for the day. Time to sit down and enjoy the harvest of 1994.

Fig. 24 (fold out)

9100 SARDIS FOREST DRIVE 704 . 847 . 1107

CHARLOTTE, NC 28270 800 . 235 . 7939

Vietnamese child

L a t e n t
I M A G E S
A PUBLICATION OF PAUL EPLEY PHOTOGRAPHY

Fig. 25 (front)

"You Don't Have To Get Your Brains Blown Out !

What else can you do besides survive in the jungle, shoot and blow things up?" he asked.

I had joined the Army to fly airplanes and ended up jumping out of them. Not exactly like that Army recruiter had promised. And not exactly what I had expected.

"Welcome to Vietnam!"

screamed the old sarge as he handed out the placement orders. After jungle and airborne schools, driving for a general would be a snap.

It was a snap all right. Snap this and snap that. Peel these and polish those. Be here and be there and all at the same time.

Life as the lowest rank on the general's staff wasn't fun, but it was safer than a line unit. At least it was for my two days.

"Westmoreland's been here, ordered staff cuts and five of you six drivers will have to go," Colonel Holecomb announced. "I have found reassignments for every one but Epley."

Had there been time to sleep I would have been sleepless. He gave me five minutes to cram all my gear into a duffle bag and sweat my way to his bunker.

"When I get back from staff meeting, you will be leaving. Have some ideas," he quipped.

"You've got about forty-five minutes to come up with somewhere I can send you; or with all your jungle training, I'll have no choice but to send you out to a line unit."

By now I was soaking wet in my own sweat and just a tad anxious.

A chance to pick my own reassignment and me totally clueless. What could I do?

My brain was a bee-hive of activity as ideas buzzed in and out. Then I saw him.

Bounding out of the command bunker, he double-timed through the sandbag maze and into the full brillance of the afternoon sun. He was coming for me and he was coming fast.

"Holy Mother of Pearl!"

I thought. "What Can I possibly tell him? What else can I do?"

The light bulb- I remembered seeing it on my first night in country. Motionless, covered with dust, its pulsing filament lighting the faded sign,

P R E S S C E N T E R .

At 3:00A.M., the road from Siagon to Ben Hoa was dark, damp and dangerous. Diesel fumes engulfed the old bus as visions of an unseen enemy filled our thoughts. The night's only relief came from fleeting gust of acrid air through the rifle slots.

Fig. 25 (back)

Promo Pieces Based on Client Projects

Client projects create opportunities for promotion pieces. J.W. Burkey used the equity in a "household name" client to produce his latest promo piece (Fig. 26). Stan Sholik used the co-op approach of combining the talents of a team of services for his promo (Fig. 27). This has always been a popular approach for producing photo promotions. Warning! Be careful using this approach for your primary pieces as they are rarely produced on any kind of deadline or schedule you can count on. This isn't bad, it is just very difficult to get three or four firms together to voluntarily produce a promo!

Another great use of a client printed project is the "backprinting" of a client's piece. For example, Stan Sholik took several hundred of his client's four-color "food" piece and simply sent them back through a one-color press with his food capabilities brochure printed on the back (Fig. 28).

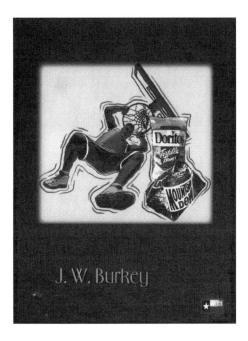

Fig. 26 (front)

Some only dr$_i$b$_b$l$_e$.

Some only p a s s.

Some ne**v**er get
off the bench.

J.W. *always* plays **above**
the **rim**.

J.W.'s latest **slam**
dunk
is for Pepsi's
"March Madness"
national promotion.

For *images* that
shatter the backboard,
call 214-746-6336.

He shoots. He scores.

Fig. 26 (back)

Fig. 27

Changing Taste
for a
Changing World

Try our Enchiladas Today!
Another popular nutritional

 CAMINO RE

Fig.28 (front)

FOOD
PHOTOGRAPHY

MARIA
MARIA PISCOPO
20SS0 CALVERT
COSTA MESA, CA
92626
(714) 556-8133

STAN SHOLIK
STILL LIFE PHOTOGRAPHER
3200 square foot studio with 35mm through 8x10 camera formats

Represented by **Maria Piscopo** (714) 556-8133
FAX (714) 556-0899

Specialties: 10 years experience shooting packaging, food services and products.
Large format close-up and macro photography.

Facilities: Full kitchen (450 square feet within 3,200 square foot studio) which includes
a 6-burner Wolf range, commercial refrigerator and freezer, microwave,
dishwasher, Kitchen Aid Mixer and Cuisinart. There's also a client
conference area with a Lucygraf, copier, FAX and an extensive library of food-
industry publications and cook books.
1946 East Blair Ave /Santa Ana, CA / (714) 250-9275. Off Deere, west of
Redhill Ave., between Dyer and Alton.

Clients:
Alex Foods
Bridgeford Foods
California Avocado Commission
California Deli Council
Camino Real Foods
CoCo's Restaurant
Hunt-Wesson
Lamppost Pizza

McDonalds Restaurant
MCP Foods
Spires Restaurants
Sunworld
Supreme Yogurt
Teddy Bear Yogurt
Taco Bell
Western Bagel

*"We find Stan and his staff do not have the ego problems I've seen with other studios... problems
that got in the way of a good working relationship."*

*"Out of all our vendors, the chemistry with Stan, the food stylist and myself really stands out as
unique."*

*"Stan takes the consumer's point-of-view, he is always curious about how the audience is going to
see the food we are shooting.... he understands how they feel... even how a food editor will respond
to a recipe... and prepares for the photography accordingly."*

Steffne Miller, Public Relations Manager

Fig.28 (back)

Non-Traditional

When you have done everything else, be creative! Being creative does not mean spending a lot of money! These promo pieces tend to be best used for name recognition and reminder, rather than traditional selling promos. Other than the been-done-before coffee cup and rolodex card, what can you do? Again, your marketing plan will dictate your specific direction, but here are some ideas. Mark Culbertson printed notepads, really nice ones, with one of his favorite images. He uses them along with a traditional promo for a portfolio presentation leave behind (Fig. 29). Paul Epley finds his simply produced and printed one-color thank you cards (die cut to add a business card) very popular and memorable among clients.

For the ultimate non-traditional promotion, how about a mouse? That's what rep Tony Luna asked of his photographer Dan Wolfe. The actual mouse pad went out to art directors and producers (all qualified as working on computers) with a cover letter that let the client know they wouldn't have to go through all the trouble of using their rolodex for calling them with a job (Fig. 30).

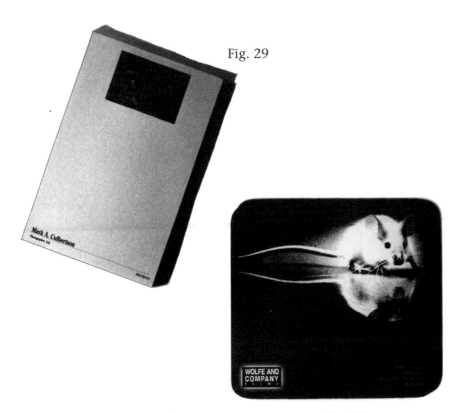

Fig. 29

Mark A. Culbertson

WOLFE AND COMPANY

Fig. 30

Public Relations

Public relations is an excellent, but under-appreciated, form of promotion for photographers. Simply defined, it is getting people to know you (and know of you) through the media, as opposed to exposure you can buy with advertising. In today's tight economy, being known and having credibility can give you a cost-effective and important competitive edge. It is underutilized because most photographers find publicity an enigmatic and intangible process. With a little planning and research, you can easily add publicity to your self-promotion plan.

First, let's dispel a myth. You don't get publicity just because you're a good photographer. You get it because you ask to be considered for it! It also works to strengthen and support your advertising and direct mail (by adding credibility) and selling (by letting people know who you are before you call!). A major benefit is the creation of additional promotion material from reprints of any publicity. You can use them to mail or distribute to clients to supplement the materials you plan and produce. (Figs. 31, 32).

There are three parts to planning publicity for your photography business:

- Planning and writing press releases
- Entering and winning awards
- Planning events and promotions

BINESS SUNDAY, APRIL 24, 1994 THE DOMINION POST 3-D

Emotional impact pictures produce big-name clients

BY KELLY BARTH

The Dominion Post

FAIRMONT — He counts among his clients: Oliver North, Mary Lou Retton, Pittsburgh Brewing, DoubleDay Books, Paramount Pictures and Lang's Fashions.

Not bad for a guy based in Fairmont, West Virginia. Paul Audia's craft is photography. That is photography with "sensual, emotional impact."

A few months back, Audia's work caused something of a stir when it appeared in the West Virginia Development Office's magazine "Industry in West Virginia." There, on page 35, in the midst of a series of traditional company profiles was an ad for Danser, Inc.

Half of a two-page spread was devoted to Vacuduct, one of the ductwork manufacturer's newest products. The cutline proclaims; Vacuduct can withstand temperatures in excess of 2000 degrees.

The stir: posing with Vacuduct was a scantily clad female model. Audia acknowledges that the ad offended some, but the reality is that when people go to Audia they know what they're getting.

"In every circumstance, in every person, in every product...there is emotion. I'm not just shooting film. I find the sensual side and use those emotions along with technique and creativity to create images which capture your attention," Audia said.

More and more, Audia is building the commercial side of his business, although he still owns and operates a portrait studio. Clients aren't shocked by his work because they've usually come to him in search of something a little off the beaten path of local photography.

"You work to please your client, but you owe them something more...a step beyond their own imagination and into your

Paul Audia, in a self portrait

personal style. We both want a visually compelling and memorable image, but artistically I try to go one step further. It's an educational process for my client and me.

"We're known for our creativity; in fact our clients expect our portraits to look completely different from what everyone else in my area is doing," Audia said.

Feelings, Audia said, are what makes photographers different from one another. No two experience the same feelings. An example Audia uses to explain that is a bowling ball.

"If 10 photographers photographed that bowling ball you would have as many different images as you had photographers."

Audia said it's easy to find a niche and stay there, but for him, "necessity dictated me to be different."

Audia tries to spend at least two weeks a month in Fairmont. The other two weeks he's usually traveling, broadening his scope as he breaks into the competitive world of commercial photography.

The difference between that and the portrait work isn't the technical skills, it's the frame of

mind, Audia said.

Anyone who has seen the burgeoning Christmas classic, "Scrooged," has seen Audia's work, if only for a fraction of a second. It's the scene where Bill Murray spots Fairmont's own Mary Lou on a cover of "Inside Sports."

Audia met Oliver North during a trip to Detroit to shoot a wedding. They hit it off and Audia got to do the portrait for the jacket of North's autobiography, "Under Fire."

Audia's become accustomed to the occasional West Virginia stereotype bias as he weaves his way into jobs in the national and international commercial photography market.

But Audia knows he can be just as resourceful as photographers with more metropolitan roots.

On a trip to New York Audia stopped by the offices of Calvin Klein hoping to make a contact or two. Nary a piece of paper or file cabinet anywhere on or around the receptionist's desk. As Audia waited in the ultra-modern reception area, in walked none other than Calvin himself. He and some company executives filed past Audia into another office.

During Audia's wait, he struck up a conversation with the receptionist.

She admired one of Audia's photographs and so he made her a deal. If she promised to leave the print in a visible place on her desk until the executives filed past after their meeting, the print was hers.

The receptionist agreed, but Audia never heard anything from Calvin Klein or one of his underlings.

"I don't even know if anyone ever saw it. But nobody could have seen it if it wasn't there."

Fig. 31

THE SET UP

Up Close

BY STAN SHOLIK
Stan Sholik Photography
Santa Ana, CA

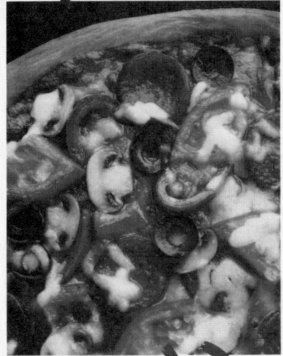

'Pizza! Pizza!' Nothing makes a mouth water more than a close up shot that makes food look real!

and Real!

Sholik's large format close-up macro style demands attention from the viewer, a very successful technique for Sholik and a very different viewpoint clients drool over.

T his image was made for photographer Stan Sholik's portfolio, applying his large-format close-up/macro style to food photography.

According to Sholik, four uncooked pizza crusts were purchased for the shoot. The home economist used one to make a sample (stand-in) for the final photo. The stand-in was made up with several different combinations of possible toppings and cooked to determine the correct oven time for the crust. When cooked, the stand-in was placed under the camera and image magnification and lighting were determined. After taking Polaroids of different sections of the stand-in, the layout of the toppings for the final pizzas was determined.

Three more pizzas were prepared by the home economist. After removing them from the oven, one section of one pizza was determined to be the most photogenic and this was placed in position. A Polaroid was taken and final adjustment of the toppings was done. Just before shooting the final film, the home economist passed a hot electric paint remover tool over the pizza to put a fresh melt on the cheese and liquefy any fats on the pepperoni that had cooled.

Sholik used an 8x10 Sinar P2 camera with a 12-inch M-Nikkor f/9 lens. Magnification was 2 to 1. Kodak Ektachrome 6118 Professional (Type B) film was warmed with a 0.5Y CC filter exposed for 8 seconds at f/32. A Colortrans 6-inch Fresnel spot containing a 1000 watt, 3200 Kelvin bulb was positioned to the upper right and softened by a 3x4-foot diffusion panel. Reflectors to the right and bottom provided fill.

"In advertising photography, clients are constantly looking for a unique viewpoint from which to display their product," says Sholik. "Large-format close-up and macro techniques can provide such a viewpoint in food photography since they are not widely used."

Not all subject lend themselves to these techniques, however. "Sometimes the problems are technical," Sholik points out. "For instance, if there is too much depth in the subject for the limited depth of field necessary for these techniques. Other times, the subject matter is simply inappropriate, like when you're photographing crayfish and snails." When it does work, however, it provides a unique and exciting perspective that demands the attention of the viewer. ∎

Fig. 32

Planning and Writing Press Releases

The most common tool of public relations is the press release. The press release is a standardized form of communicating some "newsworthy" item to the editors of publications. Upon evaluating your press release, the editor then decides whether or not to publish your story. There are no guarantees. The value of publicity is the acceptance of your submission. It is a form of third party endorsement and promotes credibility. Anyone can write and submit press releases! You start with a media list (list of publications) that is up-to-date with the name of the editor. It is a good idea to call first and ask for the name of a specific editor that deals with business press releases like yours. Be sure to include magazines, newspapers and newsletters read by your clients, your community, and your peers.

For example, client media could be a trade publication like *Adweek*. Community media could be your local newspaper and your peer media could be any photography magazine! Client publications seem an obvious choice to promote yourself to people that buy your photography. In addition, everyone reads the local paper and, because the goal of public relations is repeated exposure of your name and firm, some of this more "general" exposure could influence people that hire. If you are not sending your press releases to photography publications, you're missing out on the chance for referral publicity and some great reprints! All it will cost you is the time to write the release and the postage. You don't pay for the publication of your release. Here are some examples of "newsworthy" items that could generate a press release to all of the above media.

Sample Press Releases:

- You relocate or open your studio
- You add personnel to your staff
- You celebrate the anniversary of your firm
- You finish a big, important job or work with a name client
- You win any kind of award
- You expand with additional services for clients
- You participate in a community service project
- You are elected to an association board of directors
- You install important, new equipment or upgrade facilities
- You give a lecture or teach a class

The news must truly be worthy and of interest or value to the publication. Blatant self-promotion that advertises your

work will not be accepted and reduce your credibility with the editor. The more you submit, the more likely it is you will get published. When the editors get to know you, they could call on you when they have their own story ideas and need an interview or a quote. You have no control over the media, which, of course, increases the value and credibility.

The press release should be specifically designed to be read quickly and give the editor an immediate sense of your news. Include all the facts (who, what, when, where) in the first few sentences without flowery descriptions or adjectives. Double spacing allows the editor to work right on the release, adding comments or editing notes. The date and the phone number at the top are required information and the ### at the end indicates there are no following pages. Always write in the third person and don't forget to enclose a photograph! Here are sample press releases. Follow the format exactly!

Sample "Gave a Lecture" Press Release

IMMEDIATE RELEASE
(Today's Date)

For Information:
Maria Piscopo
714-556-8133

(room for headline)

SANTA ANA, California... Stan Sholik, of Santa Ana-based Stan Sholik Photography, was a featured speaker for the October program of the Advertising Production Association of Los Angeles, "Measured Photography—Exploring The Relationship of Photography To Reproduction." Over 200 art directors, designers, photographers, and advertising production managers attended the evening program at the Beverly Hilton Hotel. Sholik discussed how he has used the measured photography technique for his advertising photography clients in the food, medical, and computer fields. In addition, Bill George of Eastman Kodak gave a multi-media presentation on the subject and Jay Lawrence of Solaris Communications gave a creative director's perspective on the advantages of this new approach to photography for reproduction. This photography method allows Sholik to match the tonal ranges of the color transparency more closely to the range available for scanning and producing color separations. This measured photography transparency is then reproduced more easily and efficiently by the color separator.

Sample "Interesting Project" Press Release

IMMEDIATE RELEASE
(Today's Date)

For more information:
Ina Kramer
212-779-7632
Fax 779-7635

DIGITAL IMAGING PROVIDES "FORTUNE 500" QUALITY PHOTOS

SANTA ANA... Stan Sholik, owner of Stan Sholik Photography, has expanded services for Pacificom Advertising with the combination of Sholik's original photography and digital retouching of the client's implant lens products. Previously, this had been handled by different outside suppliers. Art Director Harold Bishop, comments, "These highly detailed product photos have always needed extensive retouching due to the frailty of the lenses and for other areas of the lenses that typically need cleaning up.

"With his in-house digital capabilities, Stan made it possible to create a thoroughly clean and absolutely perfect-looking product, faster than we have ever had the work done before. This allows me to produce the 'Fortune 500-quality' my clients expect from me." The output for the photograph of the two silicone implant lenses was a 4x5 transparency at a very high resolution so that the graduated background would retain the smooth gradation the client required and no digital artifacts or "stair-steps" would appear at the edges.

Stan Sholik has been an advertising photographer based in Southern California for twenty years and is working on a series of articles and lectures on electronic imaging.

###

© 1992 Stan Sholik

STAN SHOLIK
PHOTOGRAPHY

Black and White Photography Breakthrough

For the times that you need to cut through the advertising clutter, but your concept or budget calls for less than process-color reproduction, Stan Sholik Photography introduces *Direkt Skan™* black and white photography. Where the ultimate in one-, two-, or three-color reproduction is desired in advertising, collateral or annual reports, no other black and white process comes close. And if your budget permits four-color black and white, reproduction like that on the reverse side can be achieved. Best of all, *Direkt Skan™* costs no more than conventional black and white photography. Exclusively at Stan Sholik Photography.

Ultimate quality for a competitive price. For additional information, call Stan Sholik Photography for a portfolio review of *Direkt Skan™* photography.

Stan Sholik has been working with clients for 19 years. His efficient, cost-effective, creative solutions make your concepts a reality.

(714) 250-9275
1946 EAST BLAIR AVENUE
SANTA ANA, CALIFORNIA 92705

Fig. 33

Sample "Expansion of Services" Press Release

IMMEDIATE RELEASE:
(Today's Date)

For Information:
Maria Piscopo
714-556-8133

(room for headline)

SANTA ANA... Stan Sholik, owner of Stan Sholik Photography, has expanded his photo studio's services with the addition of Direkt Scan Photography. This photographic technique is a higher quality yet more cost-effective alternative to traditional black-and-white printing. Direkt Scan Photography provides clients with a new look in black-and-white, one-to-four-color reproduction to cut through the clutter of advertising images and get more attention. Advertising agency art directors who have used the process feel its sharpness and tonal range reproduction make it a better photography value. Direkt Scan Photography is offered exclusively by Stan Sholik Photography in all film formats from 35mm to 8x10. For samples, fax request to 714-556-0899.

###

Don't forget to include visuals or photos whenever possible (Fig. 33).

Entering and Winning Awards

Publicity comes from winning any type of juried or non-juried exhibition or any publication of your work. It also gives you a wonderful opportunity to write a press release. But it is very important to realize you don't have to win to benefit from the entry you've submitted. Great advantage can be gained because, in many award programs, the jurors are the editors and clients you are trying to reach with your press releases and promotions! Like press releases, the more you submit, the greater the chance of winning and generating recognition. For maximum benefit, the announcement of your winning entry can be incorporated into your next direct mail or advertisement. In addition, be sure to submit your work to publishers of annuals and "best of" books. Submitting is the key to publicity!

Finally, you can publicize, build name recognition and help clients get to know you by "non-selling" promotions. Here are some ideas you can use to promote your photography:

Professional Associations

Participating in professional associations is the perfect opportunity to come into contact with your clients when you're not selling to them. It is always easier to do this when you have an official responsibility. For example, as Program Chairperson of your local photography association, you get to call on clients as potential speakers for your association. Or, as Hospitality Chairperson for an association your clients belong to, you get to greet new arrivals at meetings.

Community Service

Working on community service projects brings you into contact with influential community leaders that do a lot of public service. It is also a great way to get printed work for your portfolio (Fig. 34).

Writing Articles

Writing photography articles for any media gives you the initial benefit of the exposure from publication and reprints of the articles can be used as promo pieces.

Speaking at Seminars

Speaking at association seminars is a great way to meet potential clients and gives you the chance to write a press release. If you're new to this kind of promotion, start out with presentations on a panel of speakers—less pressure on you!

Hosting Association Events

Hosting association seminars at your studio is especially beneficial to the studio photographer. You have to figure if a client found their way there once, they can do it to give you a job the next time.

Exhibits and Events

Sponsoring an art exhibit or community event at your studio is a nice option. It is less pressure on you and may even be a more attractive proposition for your clients.

Photographer makes presentation

.Clayton A. Fogle, photographer, is one of the Headliner speakers at the Sept. 16-19 Hummer/Bird Celebration.

"Awesome" is the word for the Clayton Fogle experience. His wildlife photography is nationally acclaimed, with magazine credits including *National Geographic, Bird Watcher's Digest, Birder's World, Wild Bird, Zoo Life* and *Peterson's Photographic Magazine*, to name a few. Put all that talent into a fast-moving, eye-catching multi-media slide presentation, all flashing at once on the big screen, and you have an unforgettable experience.

An entertaining speaker, Fogle complements his own film work with an intriguing array of dialogues and narrative. His program will cover the nesting, flight and behaviors of the hummingbirds of the United States.

Fogle will be bringing his program, "Birth of a Flying Jewel," to the screen on Saturday, Sept. 18, at 8 p.m. and Sunday, Sept. 19, at 2:45 p.m. Both programs will be in the ACISD High School Auditorium.

Fig. 34

Be Creative

Or, just be really creative! Remember the objective of all publicity and non-selling promotion is to get attention! Photographer Paul Audia has had some very interesting publicity "events":

- Sent a client a five-hundred pound block of ice in the middle of a New York summer with a poem about breaking the ice and giving him a try.

- Sent a tap dancer with a "singing bid" into the office of an art director for a retail fashion clients.

- Included a cassette tape with the theme from the movie, "Rocky" with a traveling portfolio to help inspire the art director viewing his images.

- Ran a "Toss The Teach" promotion for a local high school where the teacher with the most votes won (or lost, depending on how you look at it) and got to go skydiving with an instructor hired by Audia. When a local radio station picked up on the promotion, Audia got a tremendous amount of (free!) advertising on the station for his efforts. In addition, Paul skydived into a local mall's parking lot during their grand opening (more publicity) as the kickoff for the above "Toss The Teach."

It is important to remember you are not selling anything when you are doing publicity efforts. You are simply increasing the number of contacts with your clients, their awareness of your services and your chances of getting work. Some of these activities will provide opportunities for press releases as well as contribute their own public relations benefits.

Start today to incorporate public relations in your self-promotion plan. Get a file and start clipping every mention you find of photographers in the media to give you an idea of how stories are written. Schedule a quarterly press release and you'll be more likely to come up with something newsworthy than if you just wait until something happens. Research all of the publication submissions and award entries that will bring you recognition. Plan to use at least three of the above promotion ideas in the next twelve months. Use publicity to help promote your photography!

Association Marketing

One of the most important skills of the successful business owner is *networking*. Even in the photography business, people will hire people they know! Networking among associations is not selling or any kind of "hard" promotion. It is simply the connections and relationships that develop on a personal level that fall outside traditional and direct tactics like portfolio presentations, mailings, and advertising. The best marketing plan is to layer your direct marketing efforts with the softer sell of networking for maximum effectiveness. In addition to being more effective, you'll also increase your marketing equity. That is, each promotion effort will be worth more than what you paid when it has the support of the complimentary efforts of association marketing.

There are three types of associations to identify and network with: client, community, and peer. Your best reference for identifying different client industry associations is the "EA Directory" or *Encyclopedia of Associations* available in the business reference section of your local library.

Community associations are readily identified by your local Chamber of Commerce, or even the phone book. Then, you have your national photography and graphics industry associations.

For most of the benefits, you must be a member of the association. Of course, association dues are not only tax deduct-

ible but should be considered as essential an expense as paying for promotional material. As you read each section below, cross reference to your current marketing plan and analyze what items can be put to work immediately!

Client Associations

There are six ways to incorporate associations of your potential clients into your marketing strategy.

Newsletters Are Excellent for Advertising and Publicity

Look for client associations that produce newsletters for distribution to their membership. These can be excellent avenues for both advertising and publicity. The ads you buy can be anything from business card size to full page. Because the circulation is reasonably small compared to many of your other advertising opportunities, your ad rates will be low. Don't be misled by the small circulation! Even if there are only three hundred printed, each is a targeted client for your photography, and not a "shotgun" mailing to thirty thousand people in order to find the three hundred qualified clients! When you are concerned that the production values are not high enough due to the smaller ad rates and productions budgets, ask for their free standing insert or ad insertion rate. This will allow you to print your own ad and have the association insert it before mailing to members.

Association Membership Directories

Look for client associations that produce directories of their members. This will provide you with a source of leads for making portfolio presentations and looking for assignments. In addition, your (probably free) listing in the directory is a supplementary advertising tool to the perfect "captive" audience. Imagine being among a small, select group of businesses listed under "photography" in the resource section of your client's association membership directory!

Association Databases

Look for associations that offer their membership database on disk to save time keyboarding the names and addresses into your computer. There you have your labels for your next direct mail campaign.

Qualified, High Quality Clients

A major advantage is the quality of the clients you'll find when you market to associations. First, any company that takes the time and money to participate in their own industry association tends to be more aggressive about their marketing and promotion. In other words, they are more likely to use your photography than companies that stay "home" and keep to themselves. Second, every association has recognized business practices and ethics. A client that has their own are more likely to recognize yours!

Bread and Butter Work

Though your association client contacts may not always have the work you want to do more of, they can be very good for the "bread and butter" work every studio needs to pay the rent.

Get Involved

Finally, look for client associations that have awards programs and active committees you can join and get involved with. For example, the Hospitality Committee is an excellent choice. There's no easier networking than being the official "greeter" at a meeting. Volunteer for different committees and positions, join the board and try to work with as many people as you can. Ultimately, this is the best way to get the experience working with a potential client you often need to get paying jobs with them.

Community Associations

These are groups that range from national associations such as the Braille Institute to your local humane society. There are two areas to be added to your marketing strategy that come from networking with a charitable, community association.

Centers of Influence

These are people in the community that are the movers and shakers. People you are not likely to run into and have lunch with on a whim! Though they may not directly buy photography they influence people that do buy your services. Their relationship with you is an endorsement that could be a valuable marketing asset.

Public Service Projects

Probably the number one association marketing benefit is your participation in public service projects in the community. They

often bring together some of the community's best creative people. This is usually because, though these charity groups don't have large budgets, they do give "free rein" on a lot of the design and photography. In addition, they sometimes get high-level production values by adding a printer or paper company to the all-volunteer creative team. Most of all, you get all the benefits of a "real" job: client reference, testimonial, publicity, printed pieces—even the chance to work with potential clients!

Peer Associations

Marketing yourself through a group of your peers is the most neglected and overlooked tool of association marketing. Joining and participating in your peer association should be considered a requirement of business and not an option. Here are some of the benefits from joining or renewing your dues with your photography association.

Professionalism

First of all, you can't really be a professional in today's marketplace with out being able to show yourself as one. The quickest and easiest for any client to evaluate you are your professional associations or affiliations. They speak for themselves! So don't leave home without one....

Don't Be a Loner

As a member, you will get more information from being connected than being the traditional loner or non-joiner.

Don't Overlook Referrals

Often, fellow members refer assignments to you. When they can't or won't take the job, you are their "backup" and get the job referred to you!

People Skills

Finally, association marketing gives you the opportunity to practice all the skills you are learning—or learned and forget to use—that come with running a business. If you want to learn publicity and introduce yourself to the local and national industry media, join the publicity committee. Want to overcome your reluctance to call total strangers and get them to give you work? Then, join the membership committee. Peer association membership gives you a safe place to practice skills you can't get in school or with your clients.

But What Are You Really Selling?

Whether you are selling to a small town or to a major metropolitan market, there are similar things that your potential clients need to know before they make the big step to hiring you. We'll review these, then we'll look at "relationship" selling versus "needs" selling, two very different approaches. Finally, we'll examine the steps to effective and job-getting portfolio presentations.

What Prospective Clients Need To Know

Everyone has had the experience of looking at a photography project and asking, "How did they get that job? I could have done so much better!" When this happens, you are probably looking at a photography/client relationship based on factors other than the photography. Somewhere inside every photographer there is a little voice that says, "But I'm good, why can't clients just call me?" Other than recognizing what you can do for them from your self-promotion, let's look at what clients need to know about you. This personal knowledge of you is necessary because every client you are selling to already has photographers they work with. By adding these factors to your sales presentations, ads, mailers, and promos, you help the client move you from the vast pool of photographers they have seen to the smaller pool of photographers they would consider calling when they have work. This is your highest objective of

selling—to move yourself in the mind of every potential client—from the big pool of "unknowns" to the pool of "knowns." In some industries, this is called the "short list." That is, literally a short list of firms called for work. That's where you want to be!

How To Get On The "Short List"

Photographic Ability

This is almost a "given" in today's new marketplace for photography services. It is clearly seen in your work, but at the same time, there are a lot of technically competent photographers. When you have a hidden technical capability, it should be brought out to give you a competitive edge.

Give the Client What They Want

A tricky subject. Lots of photographers would like to show their highest level of creative ability in their portfolios. Unfortunately, lots of clients find they can't relate to the work! Before you put together your next sales presentation, be sure to determine whether your client is interested in creative collaboration or a preconceived image. Both are right—neither is wrong or bad. The client that buys creative collaboration looks at style, personal vision, and the way you see things. This is how a photographer that shows all jewelry in his or her portfolio gets hired to do a car shoot. This confuses many photographers when they are not clear on the distinction between the two types of client. The image-fulfillment client wants to see what they need before you shoot it. In the past this has been called the "red shoe syndrome" where the photographer that shows any other color shoe in their portfolio will not get the job because the client figures they can't shoot red shoes if they don't show red shoes. Simply know who you are talking to and present the appropriate portfolio.

Make Them Look Good

This is another difficult subject for clients to discuss openly. Your best bet is to be very aware of the potential competitive edge and added value this factor gives to your photography. Try adding "case study" anecdotes when presenting images so that you have a better chance of making the leap to the short list. Remember, this leap is made when your prospective client can see themselves working with you. You can do this by the example of your work with other clients or on a public service project where you made the client a hero.

Create The Perception of Effortlessness

Every client's dream photography project is the one that eases their frustrations and meets their challenges. Your presentations should address this issue because every client is thinking of it whether they admit it or not. In addition, it provides a counterpoint to the client's comment, "We're happy with our current photographer." There is always something the current photographer has done to frustrate the client or make a shoot difficult. This could be your way "in the door."

Be Flexible

From here on, the problem with the factors is that they are about the working relationship. How will the prospective client get to know you are flexible until they've worked with you, if they won't give you a job until they know you are flexible? You can demonstrate flexibility in every contact you have with a client. Starting with the first phone call and through bidding on your first job with them. By the way, flexibility does not mean dropping your price to get the job. Chapter 13 explains why this is true.

Work Within Deadlines and Budgets

Again the case study approach to your sales presentations and marketing promotions is the best way to demonstrate this very important factor. Think about it, can a client tell the photo shoot came in at budget and by deadline by just *looking* at your work? No! You've heard the old saying, "The portfolio speaks for itself"? Your problem is that it doesn't speak to what the client can't see.

Be Easy To Work With

Simply put, no prima donnas. An aggressive temperament won't build the kind of long-time relationship you are looking for in a client. They may use you once or twice because they have to (or don't know what they are in for), but they won't come back. An assertive attitude accomplishes the same objective of getting what you need and want out of the client, but doesn't drive them crazy and make you impossible to work with!

Can They Trust You?

A pretty vague area, but there are some specifics you can demonstrate at the presentation and promotion stage. These in-

clude: not talking badly about other clients you have, not putting down your competition, not having other client's work lying around in full view when they visit the studio. Knowing the client's concern for trustworthiness may be all you need to do.

How Will It Work?

Ultimately, this isn't about you or your client. Photography business is about accomplishing the client's objective. Demonstrating your ability to do just that—no matter how small or large the objective—will help you get on the short list. It also adds value and gives you a competitive edge.

How Will You Help To Do Their Job?

Time is the currency of the nineties. A clear competitive edge can be gained when you can demonstrate to your prospective clients that your current clients are more productive because they work with you. Again, case studies make good demonstrations, and you can add client testimonials as evidence. Like most of these factors, your images alone will not help the client get to know these things about you!

Which Approach To Selling Is Right For You?

Traditionally, photographers have approached clients for an appointment to show their portfolio. In today's new marketplace, this has been getting more and more difficult. Clients are too busy, pressed for time, and stressed with the changes in the company they are dealing with. Certainly an appointment to show your work and begin a relationship still works, but what if you can't get in? What if you have so many prospective clients that seeing every one of them will take forever to generate assignments?

You now have two choices for approaching prospective clients: relationship selling, where you are seeking an appointment, and needs selling, where you are looking for more information before you try to get the appointment to show your work. Here's how they work.

Relationship Selling To Get The Appointment

Step One

Ask for contact by name.

Step Two

Receptionist asks, "What is this regarding?" and your responses revolve around your specific marketing message, that is, what kind of photography you are selling. The more specific the message, the easier it is for your prospective client to determine whether they need or want to see you and your portfolio at this time. So your responses could be "Regarding an appointment to discuss food photography needs"; "Regarding the food photo promo she received" (if you sent one); or "Referred by Joe regarding my food photography portfolio."

Step Three

Simple. You will either get an appointment or not! No matter what response you hear back, Mary Client has only two possible responses to give you: "yes, let's meet," or "no, not now." Comments such as "in a meeting" or "can't come to the phone" mean the same thing as "we're not looking at food photo portfolios at this time."

Step Four

When you do not get the appointment, don't get off the phone without a piece of information that can recycle back into another contact with Mary Client. Pick any of the below or make up your own, just don't quit at this point without knowing what happens next. Possible responses:

- Who else can tell me about food photography needs?
- When to call back for an appointment?
- How to best reach Mary?
- Who else in company may use food photography?
- What kind of needs for food photography are there?
- How often does your company work with food photographers?

Information Selling To Determine Needs

This approach starts out the same way as appointment selling.

Step One

Ask for contact by name.

Step Two

Receptionist asks, "What is this regarding?" Now, your response is directed towards seeking out more information so that you can determine if you want to ask for an appointment. This sifting of clients is useful when you have a lot of leads or simply want to save everyone's time and just make appointments with the clients that are ready to work with you. This approach results in fewer portfolio appointments, but each appointment is to discuss a real need for photography. Here are some responses:

- We're updating our files, what kind of need at this time does Mary have for food photography?

- We just need information, when will Mary Client be reviewing food photography portfolios?

Step Three

If the response is positive, then go for the appointment. If Mary doesn't need food photography at this time, simply ask when you should check back. If this is a client you really want to work with, suggest that you'll send your mini-portfolio for Mary to keep until the two of you can get together.

Effective and Job-Getting Portfolio Presentations

Finally, you have the appointment and want to make the most of your time with your prospective client. There is no way to "can" a presentation of your portfolio since each one will be customized to the client's needs and responses to your work. You can be sure to cover the following points in order to make the most of your time together.

Step One

Have an introduction that helps the client focus on who you are and what you do and why you are there.

Step Two

Present your images from the client's perspective of the value to them, not the image itself. They can see what it is! What you talk about is *how you got there*. Using the factors discussed above to illustrate and give evidence of your value to them.

Step Three

Be prepared for hard, tough questions. If the client isn't asking you about price, experience, other clients (to name a few), they are not interested in putting you on the short list at this time!

Step Four

Leave behind something to help the client remember what you can do for them.

Step Five

The most important step and the entire reason you are there meeting with this client—to find out what happens next? Choose any of the questions below to conclude the meeting. Always be left in charge of the follow-up, it is not the client's job. Follow-Up Questions:

- When should we get together?
- When should I call you?
- How about a call next month?
- How do you want to keep in touch?
- When should I send more information?
- What would you like to see more of?

Step Six

As you are packing to leave, ask for a referral, "Who else do you know that may need food photography?"

Working in the Major Metropolitan Markets

If you have established your photography business in one of the traditional "big city" markets, you have a different type of client base than your peers in geographically smaller markets. For a photographer in New York, Los Angeles, Chicago— or any major metropolitan city in the world—here are some of the major differences you are dealing with.

- The client base is located in a smaller geographic area with a higher population density. Often, this means a much greater level of competition—a large pool of photographers going after a small pool of jobs. Just ask any photographer in Manhattan.

- Because you are in a more geographically concentrated market, you can be more focused on relationship selling. Your clients can be courted and sold to more often.

- Bigger cities have a greater concentration of advertising agencies and design firms. The bad news is that you are working with a very vertical (narrow) client base because you are primarily dealing with only two types of clients (agencies and design firms). The good news is that these jobs are a source of higher value based on usage, and they often have a greater volume of jobs due to their larger client (and media billings) base.

- Reps are much more common in larger cities because of this concentration of high-end clients. A rep can develop good relationships with just a few art directors or art buyers to sell dozens of jobs over a period of time. In a smaller market, you may need to develop a dozen clients to get a dozen jobs.

Promotion Strategies

The vast changes in the photo industry are more apparent (in fact, often first apparent) in the major metropolitan markets and will affect your promotion strategies.

Many Photographers Specialize To Stand Out

When you are selling to clients in these markets, you'll find a lot more specializing among photographers to stand out from the competition. However, just one or two specialties will not bring in enough billings in today's new economy. In other words, it will take a number of specialties to become enough of a generalist to build a recession-proof base. The "pure" specialist, even in these larger markets, has a difficult time! Like their smaller market cousins, photographers in large cities now want to "do it all."

Major Markets Are More Consumer Oriented

When you are in these markets, you'll find the ad agencies and design firms more "consumer" oriented and therefore more sensitive to growth vs. no-growth industries. Be sure to review such publications as the *Wall Street Journal* and *American Demographics* magazine because they frequently identify what the growth markets are. This will allow you to identify better prospects for your photography services. Also, follow the futurists and trend forecasters such as Faith Popcorn and her newsletter for the same reason. You want to go after advertising agencies whose clients are in growth industries.

Know What Subjects Agencies Are Interested In

Know, before you show a portfolio or shoot a promo piece, what subjects the agencies need to shoot for their clients. The traditional Big Three: cigarettes, liquor, and automotive have been on the decline and a lot of smaller, more-targeted markets are coming up.

Some of the new marketplace industries include: the fifty-plus age market, the new baby boom, ethnic diversity (particularly Hispanic consumers), high-tech as related to healthcare

or environmental issues, small retail entrepreneurs, business services (such as payroll or personnel agencies), leisure/travel, telecommunications, and biotechnology.

To find enough work, photographers in large cities have had to look more and more to client-direct and in-house ad agencies. Though these are much harder to research and are less sophisticated clients, they tend to be more loyal and pay faster! You'll find a decline in jobs in traditional print advertising and a tremendous growth in alternative media such as direct mail catalogs and sales promotions. Be very flexible and open to these new job options.

Also, you can no longer afford the luxury of being just a photographer, you must first be a business owner. Clients will treat you the way you've trained them to—if you act like a business owner, you are more likely to get treated like one.

You'll also find there is a much longer time between the first sales call and the first job. This means planning a more aggressive strategy for keeping clients, planning on finding the less glamorous bread and butter clients, and adding additional profit centers such as giving seminars or writing articles and books!

Multi-level marketing is very important in a larger market with lots of photographers. You'll probably need a marketing coordinator to assist with the administrative aspects of promotion (see chapter 16).

Direct mail is much more sophisticated in a metropolitan market than throwing your promo piece in an envelope! This is because of the larger pool of photographers going after a small pool of clients. In this very competitive environment, you need to design a direct mail campaign that will rise above the competition and get the attention of the buyer (see chapter 3 for details).You'll also find many more requests for drop off portfolios and mini-portfolios. This is because these bigger ad agency clients have less time for one on one personal portfolio presentations. The format of the drop off and the mini-portfolios allows you to get your work in their hands without an appointment.

Figure out how to add or create value as an alternative to cutting prices. You can always use the option of helping the client figure the hidden cost of hiring cheapest. It is up to us, clients won't do it for themselves.

Watch for industry changes due to the shift from text-based communications to image-based communications. Perhaps the downsizing of prices (fewer jobs, smaller usages) in this market can be offset by the enormous amount of images these markets will consume.

Researching New Clients

Before launching a search for new clients, you must have defined your marketing message—the type of photography you want to do more of. To create this marketing message, you will have to decide on what areas of photography to pursue. Then, this pursuit will be defined by subject, type, style, or industry. You can't find new clients if you don't know what you are looking for.

Once you have created a specific marketing message that provides the direction for your research, you are ready to look for new clients. In three steps, you will do: the primary research to build a database, the secondary research to upgrade and maintain new lead development, then turn each lead into the name of the person you'll be selling to—your true client "prospect."

Primary Market Research

Most of this research can be done at your public library. The business reference section and the librarians will be most helpful when you can tell them what you are looking for. From manufacturers to direct marketing agencies to book publishers, there is a directory for every market! Before you spend hours at the library copier with a pocketful of change, check with the librarian or the directory publishers for a copy of their book on disk or on-line. Then, you can download the information into your personal computer and use the information

for making sales calls or mailing labels.

Another note, watch for directories that have some kind of qualifier for a firm to be listed. When you are looking for new clients, you want to work with the highest level of information possible. Some directories will list a book publisher simply because it exists, while others will list only book publishers that answer an annual survey of what kinds of photography assignments are available. Here are some (not all) of the places to look for leads.

Advertising Agencies

- *Standard Directory of Advertising Agencies*
- *Adweek Agency Directory*

When looking for advertising photography assignments, there are two ways to research prospective clients. One, you are selling to an advertising agency based on the type of clients they represent, such as selling food photography to an agency with food clients. Even subject categories as broad as people or product photography can be broken down into specific client types. For leads on people photography you will look at ad agencies that have "service" sector clients such as healthcare, financial, or insurance.

For product photography, look at agencies with "manufacturing" clients such as computers or electronics. True, you do see people in computer advertising, but when doing primary research you are taking your best guess at the most-likely leads for the work you want to do.

You can also sell your personal style to an advertising agency. This kind of client is not specific to any industry or subject category. You can make an educated guess, however, and take a close look at agencies with consumer advertising clients.

Corporate Clients [also called Client Direct]

- *Standard Directory of Advertisers*
- *Chamber of Commerce Directory*
- *Adweek Client* (Brand) *Directory*
- *Services Directory/Manufacturers Register*
- *Business Journal Book of Lists* (available on disk)
- *Encyclopedia of Associations* (by industry)

These are just a few of the dozens of directories that list the names of companies that can be developed into photography leads. Watch for qualified information, such as a chamber of commerce or an industry association directory (have to be a member to be listed). Again, the value of this level of information is that it "weeds" out the less aggressive companies and leaves you with firms that are actively promoting their products and services. What can you guess from this qualifier? They are probably doing more promotion and need more photography!

Direct Marketing Agencies

- *Directory of Major Mailers*
- *Direct Marketing Marketplace*

A relatively new client for photography services, direct marketing agencies are firms that are responsible for the design and production of promotions—primarily direct mail. Since so many companies have found direct mail more cost effective than some forms of print or electronic advertising, millions of dollars in marketing budgets have been taken away from ad agencies and given over to direct marketing agencies. This is particularly good for catalog and other consumer photography projects.

Editorial/Magazines/Publications

- *Standard Rate & Data Service*
- *Gebbie Press All-In-One Directory*
- *Gale's Directory of Publications*
- *Editor Publisher* (newspaper directory)

Though the rates are often fixed at a "page rate," many photographers pursue editorial work for its self-promotion aspects:

- The credibility of having published work.
- The contacts they can make with the corporate client.
- Lots of creative freedom to pursue personal style

(Of course, the exposure to thousands—even millions—of people that read the magazine never hurt anyone's ego!)

Be sure when you pursue editorial clients you have thoroughly read and reviewed copies of the publication so that you are familiar with their own style—what they call "focus" and direction of their photography needs. Some are cutting edge, some are conservative—know who you are selling to!

Graphic Designers

- *The Design Directory*
- *The Workbook* (Directory Section)

Design firms are wonderful clients for photographers! Like ad agencies, they work with the "better" projects a company feels can't always be done internally. Like editorial clients, they work in close collaboration with their photographers and often use the photographer's perspective rather than a tightly drawn comprehensive outline of the photography. Their photography projects often have extensive shot lists, such as an annual report or a corporate capabilities brochure. Sometimes their photo needs are regular and seasonal, such as catalogs. Often more difficult to research and less glamorous than selling to an ad agency, that actually means less competition for their attention by photographers.

Paper Products/Book Publishers/Record Album Producers

- *Photographer's Market* (Writer's Digest)
- *Photo Marketing Handbook* (includes Europe & Asia)

Paper products is a very subject-specific market and great for stock (existing) photography sales. It includes publishers of calendars, greeting cards, posters and other novelty products. In this market category, photography projects or assignments are often done on a small advance plus royalty payment. Be sure to have your personal attorney or a reliable agent look over any contract before you agree to the use of your work.

Buying Compiled Information

- 9,000 firms registered with the EPA
 Dunhill Lists, 305-974-7800
- Households with new babies
 Ed Burnett Managed Lists, 800-223-777
- *Gale's Directory of Databases,* 800-347-4253
- Creative Access, 312-440-1140

The above firms are just a few of the resources available for the purchase of information compiled from credit card purchases, magazine subscriptions, and telephone surveys. Buying information is always more expensive than the simple purchase of a mailing list, but the quality of the information is higher and more qualified.

Secondary Market Research

Once you have set up a primary database, here are some additional resources of developing new leads for your photography business.

Daily Newspaper

Every day in the business section you will find news releases by companies that include: new products, expanded services, changes in personnel. Any of these are opportunities for you to get in the door with your photography services.

Trade Magazines

Check in the periodicals section of your library. You'll find magazines for every possible industry and trade. These publications, much like newspapers, include news releases that are specific to the area of photography you're interested in. You may even want to subscribe so that you can use them for approaching clients for photography services on a more regular basis.

Trade Show Exhibitor's Guides

Every industry also has some kind of annual trade show. The value of this research is that they are pre-qualified for buying photography. Many companies choose not to participate in their own industry trade show. You can make a good guess the

ones that do participate need more photography for brochures and displays than their competitors that have stayed home!

Editorial Calendars

When researching any kind of publication for photography services, the editorial calendar gives you the issue-by-issue theme for the year. Then, when you approach the publication (see chapter 10), you will be able to reference your work to a specific need they will have for photography for an upcoming issue! You can get the editorial calendar by calling the advertising sales department and asking for a media kit or by talking to the editorial department secretary. Remember, you are still in the research stage (not selling) so that you do not need to talk to a client or decision maker.

Awards Annuals

Finally, when you have a very strong visual style, you'll find that these clients tend to win the creative awards in their industry. If a client used a strong photography style once, they are more likely to do it again! Research these clients by reviewing advertising and design industry award directories and publication's awards annuals such as *Communication Arts, Studio Magazine* or *Applied Arts* (Canada).

Qualify Leads Into Prospects

In this final stage of research, your objective is simple. You will call to get the name of the true client, the person in charge of buying photography. Since this step is still research and not selling, it is very easy to delegate to your marketing coordinator or studio manager (see chapter 16). Use the role-play scripts below to get the most information with the least amount of effort. It is very important to prepare ahead for even the simplest verbal interaction! Be sure to be specific as to the area of photography work you are looking for, so that you will get the correct name. The variations depend on whether you are calling a company or agency of some kind. If you have the correct information in advance, you can even use job titles.

Your phone call script:

"Hello, my name is _____ from _____ company and I'm updating our files. Who is in charge of hiring for (fill in with a specific area of work) photography?"

"Hello, my name is ____ from ____ company and I need information on your company. Who is responsible for hiring for (fill in with a specific area of work) photography services?" "Hello, my name is ____ from ____ company and I'm updating our files. Who is the art director for the (fill in with a specific client name) photography?"

With this information, you can now decide how to proceed, based on your final marketing plan. You may add their name to a mailing list database. You may approach them for an appointment or for information. Information (the name of the prospective client) is the key.

Approaching Potential Clients

No matter how great you are as a photographer, at some point you still have to talk to people. To get appointments, close a sale, follow up—all verbal contacts with your clients you might not feel comfortable doing. After all, if you were good at talking to people, you would have probably been a salesman, not a photographer! You may have the greatest promo piece or direct mail campaign, but you will still have to talk to clients. Unfortunately, this is not a skill most photographers learn in school. Too bad, because it is one of the most important business tools next to your camera!

Rich Iwasaki (Portland, Oregon) has read many books, gone to seminars, and listened to tapes until it "finally sinks in." He says, "I spend time preparing what I want to say and planning what I want to achieve with each call. I find these calls much more productive. One technique that I find helpful is having the various 'scripts' I use in front of me when I make the calls. I try not to sound like I'm reading something, but having a sample script as a reference makes the delivery of my marketing message very efficient and successful. In the case of getting voice mail, I'm able to leave a succinct message that doesn't ramble on and sounds much more professional. After awhile, dealing with voice mail becomes almost automatic and I don't have to worry about it anymore. I also use scripts when calling prospects for information and it's especially helpful

when dealing with secretaries or assistants. Having my script reminds me to ask those other questions which make each call more productive by reducing rejection and yielding useful information. Just yesterday, I used a script for soliciting a client testimonial and my request came out in a much more efficient way than if I was 'winging it' like before."

The best preparation for any kind of phone call or talking to clients is called "scripting." This is simply a process of writing down the expected interaction between you and your client—careful, thorough preparation, just as you would prepare before going out on any photo shoot! Preparing scripts for your phone calls and meetings in order to get portfolio appointments and do follow-up is the most useful marketing tool you can develop!

Talking to clients shouldn't be done without this preparation because you want to make the best use of your time, get more information about what clients want, and have the best chance to get jobs. If you are happy with the amount of business and the kind of photo jobs you are getting, stop reading here. After all, if it is not broken, don't fix it! This chapter is for those of you that want to get more out of each conversation you have with a client.

Start by writing down the anticipated conversation as you would like it to go. Be sure to plan for all variables. In other words, no matter what a client's response, you have anticipated your reply. Not only will this technique help you get more out of every call, but you will approach the entire chore of "selling" with more motivation and inspiration. You may even like it!

Steps For Script Writing

Step 1

Open with a brief and specific introduction of your services. First you get people's attention, then you tell them what you want. For example, "Hello, I am a food photographer and my name is _____. We are interested in the XYZ Restaurants account and would like to show our food portfolio to you this week. When would be a good time to come by?" The key word here is "when." It gives you more options in terms of having a conversation than if you had asked, "may I come and show my portfolio?" The easy answer to that question is "no" and doesn't give the client time to seriously consider your request (and their needs).

Step 2

Find out what the client does or needs first, then decide what you will talk about. Talk portrait photography to portrait clients, corporate photography to corporate clients. What you do as a photographer depends on who you are talking to. Clients can only care about what they need!

Step 3

Come up with something interesting. After all, you are most likely trying to replace another photographer that the buyer is secure with. Why should they switch? You might say, for example, "Have you seen our new background samples?" or "Our photography has helped the client we worked for sell many of their products"; or "We offer consultations for those clients making the switch to digital imaging, when would you like to schedule yours?"

Step 4

Always use sentences that begin with *how, who, what, when, where* and *why* to encourage information gathering, reduce the time you spend, and reduce the rejection that comes with a "no!" For example, when showing your portfolio, ask these open-ended questions to get information, confirm the information, and verify agreements you have reached.

- How often do you use a different photographer?
- What other photography needs do you have?
- When will you be looking at bids on that job?
- Who else in the office buys this kind of photography?

Step 5

Anticipate objections and questions about your services and have very specific information you want to get. Never hang up the phone without achieving some specific objective. Get an appointment or a piece of information, anything! Successfully accomplishing any objective keeps you motivated to do this day after day. For example, when you want more information from the client, ask:

- When would be a good time to check back on that job?
- How do you feel about a follow-up call in three weeks?
- What will you look for in the bids on that job?
- Who will have final approval on the photographer?

Additional Scripting

Portfolio presentations can't really be scripted word for word like getting an appointment. They will be customized and personalized to the specific client and the photography they need. However, you can be careful to ask the open-ended questions mentioned above to get information, confirm information and begin to develop the critical follow-up relationship that leads to jobs. There are a few generic questions you can ask that will help you to set the priority of follow-up for this client:

- How often do you use different photographers?
- What other photography needs do you have coming up?
- When will you be looking at quotes on that job?
- Who else in the company works with photographers?

Don't expect these new techniques to feel comfortable at first. Anything is quite uncomfortable if not practiced regularly. You will feel like you are "pushing" yourself. What you are actually doing, is "pulling" out the information needed to get the work.

Scripts do not have to be elaborate but they do have to be written with all possible responses (yours and the photo buyers) indicated. It is simply a matter of thinking through what you want to communicate and what you want to learn from the other person. You will find your communications and presentations not only easier, but more effective. If you have ever completed any phone call or meeting and thought afterwards, "Why didn't I think of that?" or "Why didn't I mention my new portfolio?" then scripting is the answer.

Presenting Your Portfolio

ou've probably said, "This year I'm going to really work on self-promotion" or, "This year I'm going to really be successful." It's time to take a giant step in a positive direction. You need to take action to turn your dreams into solid objectives and accomplish your goals. You need to work on an updated and upgraded portfolio! You may want to get professional help. Why? Because your portfolio provides the focus and direction for your photography business. Because it is so personal and so hard to be objective. Because a clean, shining, updated portfolio will get you excited about your work and stimulate the people that see it to give you more work. Because it is probably long overdue.

Fine Tune Your Portfolio

Lauren Brill, a corporate photographer based in Chicago, sees a lot of other photographer's portfolios. In her photography business, she subcontracts assignments to other photographers. She says, "One of my favorite things is to hire photographers! I can always tell from the presentation what kind of photographs I'll get from the shoot. I was always told to fine tune my own portfolio because that is going to be the work you get, I can't believe how many photographers don't understand this. I can't believe some of the portfolios I receive from photographers to try to get work from some of the top companies in the

country. Many of them are very poorly produced and presented. I feel really sorry for the clients. The stuff they get is incredibly bad, and I would never have believed their portfolio horror stories if I didn't have the same experience myself. Everything comes back to the portfolio presentation. I know my own clients often have to re-present the portfolios they receive, and was horrified to hear one of these 'end user' clients say to her staff, 'We have been through a lot of photographers, it's time we hire a professional!'"

Don't Show a Disorganized Collection of Work

For many photographers, portfolio presentations are not as effective as they could be because they are not "packaged" or planned. Many show just a disorganized collection of work they have done, hoping the client will find something they want. This accumulation of work is not a portfolio. All the work you have ever done is your *body of work*. Out of your body of work will come various *portfolios* that show your creative side and technical expertise selected for review by a specific buyer. Each portfolio you pull out of the body of work must target the level at which you want to work (not necessarily the level you are at now).

A Polished Portfolio Can Help You Get a Rep

Another advantage to a very polished portfolio becomes apparent when you are looking for a rep. For reps, the condition of the portfolio is an important consideration when taking on someone new. The portfolio is the most effective tool the rep has. How will it show against the competition? What is special or different about it? Is it what art directors will respond to in a portfolio? A portfolio that is packaged to sell the photographer (and not just show their work) will have a greater attraction for the top reps. It will show a sense of pride, an ability to be consistent, and a strong sense of direction that tells the rep this will be a successful and lucrative business relationship.

Plan Your Portfolio Presentation

There are two major areas to concentrate on when planning your portfolio presentation. First, what you show in your portfolio and second, how you show it. Before you do anything else, however, go to your planner or calendar and schedule the time to do this work. Overhauling your portfolio is not the kind of project you can do casually. It should be treated like any assign-

ment and be given a time line and budget.

For example, when will you start working on your portfolio inspection? How much time will you plan to spend? How often will you review what you show and how you show it?

Also, you'll need to decide how much money you will set aside for new portfolio cases or presentation boards. Since you are the client in this assignment, be generous! Give yourself enough time and money to do the best possible job.

Look at the Work You Want to Get

Now, let's get to work, starting with what you show. You have certainly heard that you get what you show in your portfolio. So first you must look at the work you want to do more of in order to choose shots for your portfolio.

What kind of work do you want to do more of? Be specific as to the type (packaging, annual reports), or the industry (food, fashion, travel, healthcare, automotive), or the subject (people, product), or the style (your personal vision). Then, build your various portfolios around this work and approach prospective clients that buy that kind of photography. What if you don't have this work to show? What if you are making a transition, looking for different types of assignments or just starting out? What about the client that says, "But I want someone who has experience with my product?"

Often, the work you want to do is not the kind of work you have been getting. Paid jobs may not reflect your best work. Every photographer has done work with budget or creative restrictions that kept them from doing their finest work. Don't show it! Never include a piece in your portfolio just because you got paid to do it.

Don't Forget Self-Assignments

The answer is self-assignments. People hire you as a creative professional because of what you can do, not what you have done. So your clean-up job at this step is to pull out pieces from your portfolio that don't meet your highest level of creativity and technical ability. Once that is done (be merciless), you can more clearly see where the holes are in your book that need to be filled with self-assignments.

For example, if you want to do more annual reports, you need to create self-assignments built around the problems and solutions you would find in an annual report assignment. If you want to do more fashion assignments, select a fashion product and produce a portfolio project to promote it. Self-

assignment work is not personal work. It always has a "pretend" client and problem—along with your solution. Collect samples and tear sheets of the kind of work you want to do and then create your self-assignments from this "ideas file."

For further assistance, check in with your local creative association. Many of them sponsor annual "portfolio reviews" where you can get your photography portfolio critiqued and evaluated by reps and buyers. This means you will get specific examples of what kind of work to show and how to show it. Not being a sales call, this review can be the most honest and open source of feedback you can find!

Create a Portfolio as Impressive as Your Client List

After seeing so many portfolios herself, Lauren Brill redid her book. "I wanted a portfolio as impressive as my client list and now the whole package works. I can add work from my print files if I have to customize the book. Now, my clients are impressed with my presentation and, when I walk in with all my thoughts organized on paper (with copies for everyone), it's like holding my very own board meeting. It's actually fun!"

Your Portfolio Case Provides an All-Important First Impression

If you are the kind of person that buys a new portfolio case by whim or by what is on sale, stop and consider the impression you are giving. Clients get an immediate (often indelible) image of you at first glance.

Your portfolio case should look like an extension of you, not something that you haphazardly picked up and put together. Look for a case that has some personal distinction. A custom case manufactured specifically for your work is one of the best choices. You choose size, color, and materials along with your name or logo added to the outside of the case. If you have to shop at a local art supply store, buy the more expensive and classic leather rather than the cheaper vinyl; or ask to look through their suppliers catalogs for something just a little different or unique! Don't overlook the possibilities luggage store outlets may offer for a choice of portfolio cases.

Go for Quality and Professionalism

On the inside, go for quality and professionalism. It is possible a client will assume that if your portfolio is poorly produced or presented, the work you would do for them will be to. Worn mats, tired-looking transparency sleeves, and unmounted pre-

sentation pieces must be taken care of immediately. Resist the temptation to just throw something into a portfolio, "just to show it." It's a poor excuse for an incomplete presentation.

Reflective Art or Transparencies?

One of the first decisions to make is whether to show your work as reflective art or as transparencies. Either one can be laminated or mounted, but they don't mix well. It's really a personal decision based on your budget and comfort levels. Also, consider using the one your prospective client is most comfortable and familiar with. If you don't know what they prefer, ask them! If you choose reflective art, a photo lab can make color or black-and-white prints of your work and laminate or mount them. If you choose transparencies, the same lab can do film instead of print. It is also a sign of professionalism to have your name or logo on each lamination or mat board.

Portfolios Come in Different Sizes

What size should your portfolio be? Most portfolios today are in the range of 8x10 to 11x14 inches. This is the size of the mat board or lamination. All of your portfolio pieces should be the same size and then, inside this dimension, you can mount any size image!

How Much Should You Show?

How many pieces should you show? Remember, a complete body of work is not a portfolio. The entire collection of pieces could be dozens or even hundreds of images. Any given portfolio should be a selection of ten to fifteen boards or laminations selected for a particular client. Because each board or lamination could show two or more images, this keeps the portfolio quantity manageable while not severely limiting the number of images you show.

Reformat Your Portfolio For Your Targeted Market

Paul Epley reformatted his entire portfolio from transparency to print for his targeted market. He says, "It has been a great success. I select the print paper surface that best accents the image. I can select vibrant color punch or more subtle impact as required. The old light box hassle is over, too! No more client's projecting chromes by dirty window light or faded desk lamps. Now, the images look like their final use on the printed page. The prints are mounted on a unique mount board that

complements my other image building tools in my overall plan. It really works. I use a 'general' overview portfolio for the first call and offer follow-up appointments or traveling portfolios for more specific coverage in one of my four specialty areas. Each case has a die-embossed logo that is repeated on the custom nylon slip case protecting each portfolio. By careful tracking, I know that sixty-eight percent of my first jobs come after an average of six contacts with the same client. The print portfolio is so flexible and easy to use and ship that it becomes easy to keep images circulating to reach the magic average."

You May Need Many Types of Portfolios

Finally, how many different kind of portfolios should you create? Depending on what you are selling and who you are selling your photography services to, you could create as many as four different portfolios.

First, the "show" portfolio is your personal portfolio that goes with you to all your client presentations. Second, if you need to send a portfolio to an out-of-town client, you will need duplicates of the "show" portfolio. These "traveling" portfolios should be smaller and lighter for the ease and expense of shipping.

Third, sometimes a local client will ask that you "drop-off" a portfolio so they can easily evaluate whether they want to see you and the full "show" portfolio. This "drop-off book" is a partial portfolio designed to give the client an idea of what you can do. It should only take a small number (perhaps five or six) of images to help them make this decision and they should be bound into some kind of book so that nothing gets lost. Binders or albums also work well. Paul Audia has found good success with leaving a three ring binder after a portfolio interview. "By adding images as I send them out every three months," Paul says, "the client builds an updated personal notebook of my images."

Fourth, large clients with big jobs often need more than a single promo piece to remember what you can do and why they should hire you. You can design and produce a "mini-portfolio" that they can keep. This could be any kind of folder that holds a number of samples and printed promotional material. For example, Both Hermann Starke (Fig. 35) and Rich Iwasaki (Fig. 36) have used mini-portfolios very successfully.

In conclusion, the photography market is much too competitive to overlook the advantage of a professionally mounted and presented portfolio. So take a deep breath and get to work.

Fig. 35

Fig. 36

If you have to make even a glimmer of an excuse for a piece in order to show it, then don't show it! Yes, it will take some effort to make the time to have the proper matting materials on hand, to get that artwork to the lab for the copy transparency, and to find the money and time to do all of this. It is worth it. It is your career, your business, on the line.

Keep Clients Coming Back

There are two things you need to do to make sure the clients you find come back for more. One, make sure they know you want them and they need you, also called "The Courtship"; and two, understand the tremendous significance of the beginning of the working relationship, "The First Date."

The Courtship

Clients are often the focal point for a deluge of promotional material from photographers. Before a photographer gets that first job with any client, there is a period of time where both parties are getting to know each other. The more you know about this process, the better chance you have of getting new business in today's competitive photography marketplace. Here are some tips for this critical courtship process.

Demonstrate Technical Ability

Your portfolio and promotional material will do some of this but never assume anything! Be sure to distinguish between knowledge and skill. Knowledge means you have learned a technique and skill means you have practiced it. Always be honest. Any deception here as to your level of skill will come back to haunt you in the future. For example, perhaps you know how to photograph the facility for an annual report, but have never actually done so.

The difference is often important to the client. They will have different expectations of you depending on your accurate reporting of your knowledge and various skills.

Show Your Creativity

Beyond technical ability (the determination that you can do a task correctly) the photography client will look at your level of creativity or personal style. Now, be sure you know the culture or style of the client before you make your presentation. This corporate culture, varying from very conservative to unstructured, will relate to the level of personal creativity the firm will look for in their photographers. You can actually be "too creative" for some clients. Typically, the corporate communications person may love your portfolio, but can't figure out how to sell your unique or unusual style to the board of directors. The bottom line is know when to show your "straight" work and when to leave it at home.

Above All, Be a Professional

There are many ways a client can judge your professionalism before you ever get a chance to work together. The way you answer the phone, present your portfolio, dress for the interview, follow-up after you've met—take every opportunity to give strong evidence of professionalism.

To any client that always has to answer to the higher powers in a firm, professionalism means you will never make them sorry they hired you!

Let Them Know You Can be Flexible

What this actually means is that you will be easy to work with and solve problems, not make more than they already have. Remember, you are demonstrating this before you work together in order to get the job in the first place. The best evidence of your flexibility will be offering references or testimonials from other clients. You can tell someone you're flexible, but a third party has more credibility.

Exhibit Your Ability to Meet Their Budgets and Deadlines

This is any client's biggest dread—having to go back for more money or time for the project photography. Even though this is actually an aspect of professionalism, it is such an important factor that it will be judged and determined on its own. Failing to meet a budget or deadline is also most likely to happen

on the first job together, so the decision to hire you or not can be made or not on your ability to demonstrate this very critical point. Again, the best way is through testimonials and referrals. Another idea is to discuss it during your portfolio presentation. For example, when you are showing a brochure, mention the client's satisfaction on your timing and cost control. Don't say things like, "Here's an eight page brochure I photographed," they can see that! Talk about what they can't see—time and money saved or controlled—where their concerns really are.

Indicate Previous Experience

There's not much you can do here, you either have it or you don't and you will have to show it in your portfolio. Your experience with similar products or services gives a client the impression you can meet their needs. Bluntly put, show that you have learned the ropes at some other client's time and expense! If you don't have exactly the right product or industry experience, get as close as you can. For example, you can show financial services to healthcare clients as they are both consumer-oriented services.

Your best bet is to learn as much as possible before the interview and have the right work to show. When you don't, you have two options. You can do self-assignments or public service work to build your portfolio in the areas where you want to approach new clients. Ultimately, being able to demonstrate experience with the company's product or service will make it easier for the corporate communications director to get the approvals to work with you. Help them hire you!

Make Them Feel Safe

As a rule, a photography client will look for, and work on a repeat basis with, photographers that they feel safe working with. Your challenge is to help them feel safe enough to give you the first job! There are exceptions to every rule. When a particularly innovative corporation is looking for a unique style to use on a specific project, safety becomes less of an issue and style a greater concern. But most clients are looking for relationships they can count on and depend on to have all of the above qualities.

The First Date

Once you have that first job, there is a tendency to rush through the job estimating process (maybe the client will change their mind and give the job to someone else?). Don't do it! The way you handle this first job sets the tone and business practices for the entire relationship. Job descriptions and their cost proposal for any photography project can be very involved and complex.

Here are some tips for developing and maintaining a strong, healthy and profitable relationship.

The Budget

Always ask what their concerns or restrictions are for this project. It's better to assume they have some! Be very specific with your question. Instead of asking, "Do you have a budget concern?" ask "What are your budget concerns?" You can't always get an exact figure, but some of the other considerations below will allow you to make a good guess.

The Deadline

A very delicate subject in any client/photographer relationship. Unfortunately, because many clients have been plagued by late jobs, many photographers have the feeling they can't get accurate information on this point. Your best bet is to ask information-gathering questions designed to help the client feel more comfortable with your ability to come through for them. Instead of "When do you want this job done?" (much too subjective an issue), ask for more objective and measurable information such as "When will the annual report be mailed? How many people need approve it and how long will that take?"

By breaking the deadline into a series of checkpoints on a timeline, both you and your any client will feel more control of the process. Always be able to help your client motivate others in the approval process by giving them printed timeline material. Be a partner with your client. It is the two of you against other forces that can delay a job.

The Specific Need

Be sure to find out what specific problem this photography project is supposed to solve. The more accurate a statement from the client of the objective, the better chance you have to meet it and the more accurate the budget.

Don't take anything at face value. It is not at all unusual

for a communications department to be told to produce a brochure for the president without knowing what the brochure is for! Help your client be a "star" in their company by designing projects that meet a specific goal. Also, get all of the information on end use that is available. Not only will it create a more accurate cost estimate, but you can save your client future headaches when higher powers in a company decide they want to make that mailer you photographed into a poster.

The Approvals

Another touchy subject between any clients and their photographers. Sometimes, both are caught in nightmarish scenarios where everyone responsible loves your ideas and then someone with a higher authority shoots it down. Not only does this make your photography client look bad, but it could lose you the client! Do the most you can to protect yourself and your client—be a team. Find out how many people need to approve the project? Who are they? Where are they? Is this fax or courier delivery? Will there be consultations with you or can your client make the photography cost presentations and concepts for you? Be sure to distinguish between subjective and objective approvals. Subjective is someone's opinion and should be given only to the highest level of authority, i.e. is this the shade of red background they had in mind? An objective approval is a measurable determination of accuracy—is this the correct number of photos?

The Payment

Always work out all the details of deposits and payments at the beginning of a job. Payment for photographers is often related to the size of the client. The larger the company, the further away your client is from the person writing checks. When your client does not know how you should proceed on the issue, ask if you can talk with their purchasing department yourself. They will probably appreciate one less thing they have to do!

Today's competitive marketplace justifies a closer look at how clients look at their photography relationships and make the decisions they do. On the client's side, the same economic factors dictate a new importance and dependence on their photography relationships. The more you learn and study the relationship between the photographer and the client, the better chance you have of getting the job and turning that job into a client.

Cost Proposals:
How to Get Paid What You're Worth

The first step to getting paid what you're worth is to quote a price both you and the client can live with—and profit by! This process begins when a prospective client or customer asks the big question, "What do you charge?" To start with, they are asking the wrong question and must be stopped and corrected.

The Big Question

There are two options for photography costs. One, they want to know, "What does it cost to shoot my job?" In this case, you go on to get a complete job description and give them a cost.

Two, they don't have a job at the moment, but would like to know what it would cost to work with you when they had one! In today's new economy of buying photography, this is a more frequently asked question. It is also very difficult to answer. How do you quote a job when you don't know what they need? All the client is really asking for is some way to measure you against other photographers. Day rate can't answer the question.

Your best bet is to have prepared some simple measuring devices to give out when the client wants price, but doesn't have a job at hand. Try a price range, asking them to describe a typical job, pricing something they like out of your portfolio—anything! For a basic reference guide on assignment and stock photography, see *Pricing Photography* by Michal Heron and David MacTavish (Allworth Press).

The Job Description

When the client has a specific job request, it is very important to get a complete description of what they need before you present your cost proposal. Ask your personal version of these five questions:

- What do they specifically need? Describe the number of views, be sure to include variations! Get exact background, set, props, and surfaces as well as film and print requirements.

- When do they need it delivered? Don't forget to include any possible rush charges for a faster-than-normal delivery.

- Who will see it and what will they do with it? Great question when your client isn't familiar with copyright and usage pricing. This question will determine whether your photography will be a simple booth graphic or used for a national advertising campaign!

- What is the budget? What were they planning to spend on the photography? Clients won't always tell you, but at least they know that you are concerned. You'll get the information in a later contact with them, so don't worry if they won't answer.

- Who else is giving them a cost proposal? This question often answers the "budget" question! Again, your client may not want to give you the information, but at least you'll know whether the job is being put out for bids.

At this point, you may want to get some professional help with putting together your estimate before calling the client back. You can now buy different computer software programs that will assist you with the big question, "What do you charge?"

For example, fotoQuote is a software program for stock photography pricing produced by CRADOC Corporation in Bainbridge, Washington. Once you get into the program, you'll be prompted to choose from various usages in categories and subcategories before the program suggests a calculated fee.

In addition, you get a professional pricing "coach" included with the information from Vince Streano's marketing seminar, "Negotiating Stock Photography Prices" in the program. Vince has extensive experience in professional photography and is a particular advocate of professional presentation of your pricing.

The Verbal Estimate

Plan on calling the client back when you don't know them well or don't know if you have the job. Don't quote prices off the top of your head! Always ask to call them back. This will give you the time to do an accurate cost estimate and show your client the respect their request for photography deserves.

When you call them, try to get some feedback on that mysterious budget figure they probably didn't tell you about. This feedback will help determine exactly how much work you have to put into the cost proposal they will receive from you.

You should prepare your verbal presentation in advance so that you can handle any response. When you say, "From what you described, it will cost $5,000, how does that fit your budget?" they will respond positively or negatively. Then, before you put anything in writing, you can negotiate until you and your client agree the price is now "in their ballpark."

Considerations to Negotiate

Before the final step of presenting a nicely packaged cost proposal, you may need to negotiate your price. Never drop your price for a specified job description without some consideration made—by you or the client. Not only is it unprofessional, but it plants doubt in your client of the value of your work and you'll never get paid what you're really worth!

In addition, you'll probably lose money (if not self-esteem) on the job and that client will try getting every other photographer to drop their price without a reason. You can always walk away if you are not willing to negotiate or the client simply can't come close in their budget to what it really costs to do the work.

To avoid needing to walk away, try this one simple negotiation: When the client needs to pay less than what you just told them, they get less of something or you get more of something. Your challenge is to go into your very next pricing of a job with these two lists: client gets less and second, I get more. For example, clients can get less shots, less usage, less generous payment terms. You can get more time, printed samples, or better photo credits.

Package Your Price

Now that you and your client have a price you both agree on, you'll find that a better-looking cost proposal can be the difference between getting the photography job or not. Whether you are doing commercial, industrial, portrait, or wedding photography, a meticulous presentation of your price better

demonstrates your professionalism, expertise, and abilities. This will help the client or customer decide to hire you instead of a competitor.

As a photographer, you have two conflicting needs. One, give your client what they want at the price they want. Two, get the work you want, cover all expenses and make a profit. A good cost proposal can help you do that! To show you the best way to present your price, we will "walk-through" a typical photography cost proposal.

First, we'll look at the most basic element of any price proposal, the contract. Then, we will look at how to "package" a price to get more jobs.

The Contract

It is most effective to print contract information on your own letterhead to look as professional as possible. Standard forms and agreements are available in Tad Crawford's book, *Business and Legal Forms for Photographers,* published by Allworth Press. Please have your personal attorney check any contract before using it for clients.

Photography expenses can only be estimated and your form should state that the client agrees to pay actual expenses. The industry standard of ten percent above or below the estimate is customary and should be stated on the front of the contract. State clearly what your price includes (such as the size and number of prints) so that your client knows exactly what they are getting.

It is very important to check on the name of the person with the authority to hire you and pay you. Does your client have the responsibility to find you, but needs further approval to hire you? Break down the description into each step of the process:

- Will they select the models, props or backgrounds?

- Who will check on the location?

- Will there be a layout to follow?

- Who will approve the Polaroids?

- Spell it out!

- Don't let expenses come out of your fee. Calculate the delivery charges, special research needed, proofs—any possible expenses for the photography assignment.

When you are dealing with an advertising agency, be sure to get the client and project names. Ad agencies get lots of photo estimates and you want yours properly considered. Any alteration in the assignment could cause a considerable increase in expenses that must be approved by the client. Getting a detailed job description can mean avoiding having to go back to the client for more money to produce what they really want. Terms of a contract will vary slightly between portrait and commercial photography, but here are the basics that should be used by every photographer.

Fees

Photography fees should make a complete statement of the use of the photos. Will these photos be used just for display and exhibition or for reproduction in an ad or brochure? Ask the client or customer first.

Expenses

Client's approval will be obtained if final costs will exceed original estimate by more than ten percent. It is a good idea to get a signature on any cost overage you may be expecting! Client will pay for any changes or revisions to the original job description. So, the more detailed the description, the less you risk absorbing any of these extra expenses!

Payment Terms

Deposits should be discussed. A deposit is a percentage of the total cost (from thirty to fifty percent) that the client pays to confirm the assignment and is more common in wedding and portrait photography. An advance is payment for the expenses of costly pre-production or travel. Your invoice should be mailed when the photos are delivered or sent to your client's bookkeeping department to pay. This should get you paid within thirty days. A late payment charge (usually around 2 1/2 percent) should be quoted on all jobs. It is customary for the client to pay any legal fees needed to collect money.

Remember, unless you know you already have the job, you may need to give the client more than a contract to help the client decide to hire you. After all, you have told them what it would cost to hire you, but not why it is a good idea!

Add a Cover Letter

A good cover letter should warm up an otherwise cold-looking contract and give your client a reason to give you the job. Here is an example of a cost proposal cover letter.

Dear Robert,

Enclosed is our cost proposal for the portrait photography we discussed. In addition, you'll find the special black-and-white samples you requested. You'll find our style of portrait photography will be exactly what you need for your client's brochure. Because we have been established portrait photographers for over twelve years, you will receive the experience you need for this project.

I'll call next week to find out when you will be making a final decision on this job. We are looking forward to working with you!

Sincerely,
Maria Piscopo

Add Samples

Include samples of the work you will be doing. In this case, the client is interested in a subject expertise, portrait photography, and in a particular style, black-and-white. Never assume the client will remember the work they saw in your portfolio or promotion materials. Count on having to visually reestablish your photography credentials. This will help you get the job because you have shown you can do the work requested. Also, samples will help your client help you get the job when he or she has to present your cost proposal for decision by a committee that has never seen your portfolio!

Add Proof

In addition to your contract and samples, you can submit proof of your ability to help the client decide to hire you. This would be any item to give you more credibility and can certify your reliability.

Examples of proof include testimonial letters from satisfied clients, awards you have won, exhibits of your photography, a list of clients, references, organizations you belong to, or magazines you've been published in—anything to give you additional trustworthiness.

The Ethics of Good Business

Like any other business, there will be ethical considerations that confront us on a daily basis. The key is to be prepared by thinking through the potential situations that could arise and having some idea of how you would handle those situations.

What Are Ethics?

First, what are ethics? Ethics are the development of characteristics that will help you make a good choice of behavior. The attributes that are the foundation of ethical behavior include: integrity, honesty, trustworthiness, truthfulness, commitment, awareness or sensitivity to the situation, responsibility, fairness, and a sense of compassion.

Being ethical does not mean being weak or non-assertive! Ethical behavior is the foundation of good business practices.

Ethics Promote Good Business

Why pay any attention to your business ethics? Because your clients and peers will accept as their due the good business practices you use but will never let you forget the one time you behaved dishonorably. Because it is practical. Clients that don't feel treated fairly or honestly won't come back and it is very expensive to constantly be looking for new clients. Finally, you feel good when you do the right thing.

Recognizing Ethical Dilemmas

Ethics are not always big decisions and you are probably making good day-to-day ethical decisions without a second thought. Sometimes it can be the little things! They become codes of conduct inspired and directed by the feeling of wanting to do "the right thing." Here are some examples of the day-to-day situations you may encounter.

Think About How You Would Handle These Situations

- Delivering on all contracts, even verbal, whether it is with a client or an assistant.

- Fairly billing expenses for jobs, getting the markup you need to make a profit while not taking advantage of your client.

- Maintaining confidentiality in the client/photographer relationship. Your client should be able to trust they can have you shoot proprietary or restricted products and not have any "leaks" to the outside.

- Making honest and accurate claims in your advertising and marketing. Dealing fairly in your agency or rep relationships and abiding by the contracts you both agreed to.

As a rule, you know that you are facing a decision based on ethical behavior when you can identify the following three factors:

- Your personal happiness would be achieved at the expense of fairness or honest treatment of another person.

- Other people that will be affected by your decision are not considered or consulted and their voices are not heard.

- The long-term gain of your decision is taken as a more important consideration than the immediate gain or benefit. In other words, doing the right thing may not yield its benefit right away.

Rationalizations

How do you know you are on ethically "thin ice" when you are facing any decision? The best test is to watch for rationalizations you verbalize (or think to yourself) that you think will allow you to move ahead with an ethically poor behavior. Here are some common rationalizations:

- I'm just fighting fire with fire.
- It's not illegal, is it?
- Everyone does it.
- It's just how you play the game.
- As long as no one gets hurt.
- Whatever it takes to get the job.
- I'll only be as ethical as my competition.

Code of Fair Practice

Then, there are the bigger issues that cover day to day business practices in the photography industry. The Joint Ethics Committee has compiled a Code of Fair Practice that has been in use since 1948. Reproduced below, it covers business practices between client and photographer and agents or reps and photographers.

Introduction to the Code of Fair Practice

In 1945, a group of artists and art directors in New York City, concerned with the growing abuses, misunderstandings and disregard of uniform standards of conduct in their field, met to consider possibilities for improvement. They reached the conclusion that any successful effort must start with the most widespread backing, and that it must be a continuing, not a temporary, activity. On their recommendation, three leading New York art organizations together established and financed a committee known as the Joint Ethics Committee.

In 1978 and again in 1985, the committee revised the Code to deal with increasingly complex problems in a growing communications industry, and revised copyright laws.

Personnel

The Joint Ethics Committee has been sponsored and supported by: Society of Illustrators, Inc., The Art Directors Club, Inc., American Society of Media Photographers, Inc., Society of Photographer and Artist Representatives, Inc., and the Graphic Arts Guild, Inc.

Members of the Joint Ethics Committee are selected with great care by their respective organizations. Selection is based upon experience in the profession, proven mature thinking and temperament, and their reputation for impartiality.

Action

The Committee meets to read and act upon complaints, requests for guidance, and reports of Code violations. Proceed-

ings and records of the Committee are held in strict confidence. Typical cases are published periodically without identification of the parties involved.

All communications to the Committee must be made in writing. When a complaint justifies action, a copy of the complainant's letter may be sent, with the plaintiff's permission, to the alleged offender. Matters are frequently settled by a mere clarification of the issues in the exchange of correspondence that follows. In many cases, both sides resume friendly and profitable relationships. If a continued exchange of correspondence indicates that a ready adjustment of differences is improbable, however, the Committee may suggest mediation or offer its facilities for arbitration.

In the case of a flagrant violation, the Committee may, at its discretion, cite the alleged offender to the governing bodies of the parent organizations, and recommend that they publicize the fact of these citations when the Committee, after a reasonable length of time and adequate notice, receives no response from the alleged offender. Or, when the Committee receives a response which it deems unacceptable.

Mediation

If mediation is required, both parties meet informally before a panel composed of three members of the Committee. If the dispute requires guidance in a field not represented by Committee membership, a special panel member with the required experience may be included. Names of panel members are submitted to each party for their acceptance.

Conduct is friendly and informal. The function of the panel is to guide, not render any verdict. If mediation fails, or seems unlikely to initiate a satisfactory settlement, arbitration may be suggested.

Arbitration

A panel of five arbitrators are appointed. One or more is selected from the Committee, and the remainder are chosen by virtue of their particular experience and understanding of the problems presented by the dispute. Again, names of panel members are submitted to both parties for approval.

Both parties involved sign an agreement and take oath to abide by the panel's decision. The panel itself is sworn in, and the proceedings are held in compliance with the Arbitration Law of the State of New York.

After both sides are heard, the panel deliberates in private and renders its decision, opinion, and award. These are duly

formulated by the Committee's counsel for service on the parties and, if the losing side should balk, for entry of a judgment according to law.

So far, every award has been fully honored. The decisions and opinions of this Committee are rapidly becoming precedent for guidance in similar situations. The Committee's Code has also been cited as legal-precedent.

Scope and Limitations

The Committee acts on matters which they define as involving a violation of the Code, or a need for its enforcement. Occasionally, the Committee is asked to aid in the settlement of questions not specifically covered by the Code of Fair Practice.

The Committee does not offer legal advice on contracts, copyrights, bill collecting, or similar matters. The Committee has no judicial or police powers, and cannot punish offenders. It cannot summon alleged violators to its presence. It is, however, a highly respected tribunal to which few have ever failed to respond when invited to settle their differences.

Articles of the Code of Fair Practice

The following codes have been published and used by both client and photography organizations. They are designed to guide the relations between photographers and their clients. Since the code covers all creative professionals, the word "photographer" does not appear. The code uses the word "artist" to cover all professions.

- Dealings between an artist or the artist's agent and a client should be conducted only through an authorized buyer.

- Orders to an artist or agent should be in writing and should include the specific rights which are being transferred, the price, delivery date, and a summarized description of the work. In the case of publications, the acceptance of a manuscript by the artist constitutes an order.

- All changes or additions not due to the fault of the artist or agent should be billed to the purchaser as an additional and separate charge.

- There should be no charges to the purchaser, other than those authorized expenses, for revisions or retakes made necessary by errors on the part of the artist or artist's agent.

- Alterations should not be made without consulting the artist. Where alterations or retakes are necessary and time

permits and where the artist's usual standard of quality has been maintained, the artist should be given the opportunity of making such changes.

- The artist should notify the buyer of an anticipated delay in delivery. Should the artist fail to keep his contract through unreasonable delay in delivery, or non-conformance with agreed specifications, it should be considered a breach of contract by the artist and should release the buyer from responsibility.

- Work stopped by a buyer after it has been started should be delivered immediately and billed on the basis of the time and effort expended and expenses incurred.

- An artist should not be asked to work on speculation. However, work originating with the artist may be marketed on its merit. Such work remains the property of the artist unless purchased and paid for.

- Art contests for commercial purposes are not approved because of their speculative and exploitative character.

- There should be no secret rebates, discounts, gifts, or bonuses request by or given to buyers by the artist or artist's agent.

- Artwork ownership and copyright ownership is initially vested in the hands of the artist.

- Original artwork remains the property of the artist unless it is specifically purchased and paid for as distinct from the purchase of any reproduction rights.

- In cases of copyright transfers, only specified rights are transferred in any transaction, all unspecified rights remaining vested in the artist.

- If the purchase price of artwork is based specifically upon limited use and later this material is used more extensively than originally planned, the artist is to receive adequate additional remuneration.

- Commissioned artwork is not to be considered as "done for hire."

- If comprehensives, preliminary work, exploratory work, or additional photographs from an assignment are subsequently published as finished art, the price should be increased to the satisfaction of artist and buyer.

- If exploratory work, comprehensives, or photographs are bought from an artist with the intention or possibility that another artist will be assigned to do the finished work, this should be made clear at the time of placing the order.

- The publisher of any reproduction of artwork shall publish the artist's copyright notice if the artist so requests and has not executed a written and signed transfer of copyright ownership.

- The right to place the artist's signature upon artwork is subject to agreement between artist and buyer.

- There should be no plagiarism of any creative artwork.

- If an artist is specifically requested to produce any artwork during unreasonable working hours, fair additional remuneration should be allowed.

- An artist entering into an agreement with an agent or studio for exclusive representation should not accept an order from, nor permit his work to be shown by any other agent or studio. Any agreement which is not intended to be exclusive should set forth in writing the exact restrictions agreed upon between the two parties.

- All artwork or photography submitted as samples to a buyer by artists' agents or studio representatives should bear the name of the artist or artists responsible for the creation.

- No agent, studio, or production company should continue to show the work of an artist as samples after the termination of the association.

- After termination of an association between artist and agent, the agent should be entitled to a commission on accounts which the agent as secured, for a period of time not exceeding six months (unless otherwise specified by contract).

- Examples of an artist's work furnished to an agent or submitted to a prospective purchaser shall remain the property of the artist, should not be duplicated without the artist's consent, and should be returned to the artist promptly in good condition.

- Interpretation of the Code shall be in the hands of the Joint Ethics Committee and is subject to changes and additions at the discretion of the parent organizations through their appointed representatives on the Committee.

Photo Representatives

As competition for photography assignments increases and international markets for your work open up, many photographers look towards working with a photo representative. When considering working with a rep, it is very important to look at established business practices and industry standards. These include sample contracts, defining relationships, and even the termination of representation. You will find different versions published by The Society of Photographer and Artist Representatives, The American Society of Media Photographers, The Advertising Photographers of America, and finally in the Joint Ethics Committee, Code of Fair Practice (see chapter 14).

What is a Photo Rep and What Do They Do?

Photo reps own their own business and represent a group of non-competing "talents" that have their own businesses. The relationship is like that of an independent contractor and not an employee and employer. The photographer and the rep work together to promote the photographer to potential clients and the photographer pays twenty-five to thirty-five percent commission on the fees of jobs in the rep's territory. Photographers often maintain their own clients as "house" accounts not subject to the rep's commission. Many photographers want the rep to work with all of their clients and give all or part of their house accounts with commissions to the rep. Normally, the

photographer's general business and office management are not part of a photo rep's job responsibilities. What a rep does do is work in three important ways to build your business.

- They find new clients for the kind of work you want to do

- Keep those clients coming back again and again

- Negotiate the best pricing and terms with these clients

For each photographer they represent, reps work a geographic territory looking for a specific kind of photography assignment. Geographic territory can be limited to a city, a region, a country, a continent or the entire world! Many photographers have different reps in each of the major advertising markets around the world, such as New York, London, and Paris. Though most photographers can do any kind of assignment, to avoid conflict a rep will sell each one as a "specialist." For example, a rep might have a people photographer, a food photographer, a product photographer, and so on. Reps work most successfully when they have one kind of client that buys different sorts of photography. In other words, to bring in one hundred photo assignments a rep is more profitable when he or she can get that work from ten or twenty clients rather than have to look for one hundred different clients!

Because of this, you'll find most reps in big cities with large advertising agency clients. Because an ad agency has many different kinds of clients, they can work with a rep that has a variety of photography specialists.

When a photographer or photo studio wants a rep's undivided attention for their business, they will employ someone to act as their rep exclusively. This "in-house" rep is an employee of the photographer or studio and has all the same marketing responsibilities that a photo rep does. But, because they are employees, they do not represent any other photographers and include office or studio management in their responsibilities. They are paid on a salary or salary plus commission basis and may often have the job title of "marketing coordinator." (see chapter 16)

How Do You Know If You Are Ready For a Rep?

Here are some clues to determine if you are ready to get some help with your business and either look for a rep or employ a marketing coordinator to represent you.

- You're probably ready for a rep if you are too busy with work to make the personal contacts to find new clients and keep the ones you have.

- You're ready for a rep if you have enough repeat business from a stable client base that allows you to spend the money on the additional promotional material reps require.

- You are ready for a rep if you have a strong style or specialty that a rep can sell to clients.

- You're ready if you want to devote more time to creating photographs and want someone else to handle the selling.

- You are ready if you consider yourself first as a business then as a photographer. Reps like to work with photographers that appreciate the "business side" of their work. You are, after all, in business to make money!

- You are ready if you are willing to spend the time to assist the rep in selling your work. You will not spend less time on your marketing by having a rep. You just won't do the same things—or example, instead of showing the portfolio, you will be creating new portfolio pieces for the rep to show!

- You are ready for a successful rep/photographer relationship if you are constantly looking for ways to promote your business and need a rep's time and expertise to help you.

- You are ready if you practice good business management and run a professional business.

- You are ready if you have a portfolio of the kind of work that you want to do more of.

- You're ready if you have the budget for the promotion pieces and plans to support the above portfolio! A minimum budget for self-promotion is ten percent of your projected gross sales.

How Do You Find a Rep?

Finding a rep is very similar to the search for clients. You must research the reps, present your portfolio, and do the regular follow-up required to build a relationship. Reps are a lot like clients in that they may already have someone that does the kind of photography you want to do and good follow-up is the only way to break through this barrier to working together.

Knowing who the rep already works with allows you to approach the rep in a way that will make the very best impression. Perhaps you find out the rep does not have a people photographer and may need one. Your approach will be to help the

rep by being their people photographer so that they can offer their clients a better, more complete service.

Perhaps the rep already has a people photographer—you could offer to be available as a "back-up" and work on a job by job basis. There are many possibilities. The important thing to look at is what the rep's needs are and how you can fill them.

The Best Source

Where do you find information about reps? First, most of the creative source books list the names and addresses of photography reps. Some, like *The Workbook* (Los Angeles), list the photographers each rep represents and their specialties. You can buy a mailing list or directory of reps that belong to SPAR, the Society of Photographer and Artist Representatives (New York). SPAR also has a newsletter where you can buy an ad to find a rep for your business. In addition, Writer's Digest Books (Cincinnati) publishes a directory of representatives in the United States that lists the reps and what they are interested in repping. It is updated each year and you can order it at most bookstores, *The 1995 Guide To Literary Agents and Art/Photo Reps.*

Changes in the Rep/ Photographer Relationship

If you are a photographer happy with your rep, and a rep happy with your photographer, this won't apply to you. But so many reps and photographers are unhappy with their relationships, that the issue needs to be examined more closely. Though there are three different factors listed below that can lead to relationship problems, many problems can be traced to new reps just getting into the business and photographers unaware of the traditional formula for a successful rep business as described above.

What doesn't work very well are reps that don't realize they are in business for themselves, struggle to survive on the new clients for just one photographer without getting a percentage of house accounts, represent such a diverse and disparate group of talents that it takes a hundred clients to get a hundred jobs, rep photographers with additional reps in every major city, allow the photographer to "borrow back" the portfolio and are told to go get work and then the photographer will do a promo piece. When these situations exist, you have an unhappy photographer saying, "reps don't work." Well, they didn't have a chance in the first place! Probably the number one factor in the unhappiness photographers and reps feel for each other is the result of the major shift from selling photography to marketing photography.

Even as recently as two or three years ago, reps could rely on getting enough appointments and developing enough personal relationships with art directors to keep their multiple talents busy. A rep's job has always been to sell, one-on-one with the client. This is less true today. To find clients, photographers need to use all of the "non-personal" tools of marketing, such as advertising direct mail, publicity. I'm not saying knocking on doors (the reason reps exist in the first place) doesn't work anymore, the reality is that appointments and relationships are much more difficult to get. And how do you compensate a rep for writing a press release, planning an ad, licking stamps for a direct mail campaign? These are all tasks that take precious time away from a rep's traditional job: selling.

As the marketplace for photography grows beyond the local or regional geographic area a rep can cover, more and more photographers question the validity of giving national exclusives to a single rep. With the technology today, photographers can work with a client in Japan as simply as they can work with the client down the street. And now that they are selling ad space on satellites and space shuttles (yes, the day has come), an intergalactic exclusive is not an improbability. While a rep needs and wants this kind of very broad geographic territory of clients, photographers are less and less happy about giving it to them.

There is one last major change that has contributed to the rift between photographers and reps. That is the substitution of collateral marketing (such as a direct mail campaign) in place of the money spent on traditional print advertising. As more clients make this shift, and agencies get fewer jobs, there is less work for the rep. Suddenly, that art director with one or two jobs a week falls back to one or two jobs a month, or one agency merges with another agency, or disappears altogether.

The other problem with this shift is the effect it has on the way clients hire a photographer. With a print ad, a rep can be given a comp (usually pretty tight) and go right to the pricing stage. With collateral projects, the photography is often much less defined and the client needs to have a much closer relationship with the photographer to get what they want. True or not, this is how the client feels. Bottom line, some photographer's won't get a job because the art director doesn't know them as well as they know the rep. If the photographer has to have the relationship with the client, what (most photographers ask) is the rep's job?

It is fruitless to point out a problem without some possible solutions. Here are two options for the "new" rep/photographer relationship.

Go Back to The Beginnings

Reps can build their own businesses with some adjustments to the traditional formula such as a broader client base and greater variety of talents. Either way, no photographer is going to get the unlimited time and attention they feel they need from this kind of rep unless the rep agrees to give them all their time and attention and the photographer agrees to financially support the rep. Some photographers give the rep a percentage of gross sales and make them a partner!

Hire Someone

An entirely new job has come out of the ashes of many a failed rep/photographer relationship. This position is exclusive to a single photography studio (even with multiple shooters) and the job description covers everything from licking stamps and writing press releases to telemarketing to develop new clients. Compensation can be salary, salary plus commission, or a partnership agreement. Though I have seen this concept work very successfully (especially outside major metropolitan markets), no one has quite decided what to call it. Some options are marketing coordinator, sales manager, producer, or partner. The title of rep should not be used for an in-house marketing person because it implies there are multiple talents when there are not. Whatever option is selected, there is no doubt that reps have to reexamine their own reasons for being in business and photographers have to stop complaining and start exploring their options.

Hiring and Working With Marketing Coordinators

Traditionally, the photographer has worn all the hats in the business. Just because you are a sole-proprietor does not mean you have to work alone! Today's photography business owner may need to employ a full (or even part time) person to help with the daily chores of marketing and management. This person is not a rep. You could have an independent representative and still need a marketing coordinator, where the rep has his or her own business and other people to promote, you have the undivided attention of, and control over, an employee.

Before you say, "I can't afford to hire someone," keep an open mind. Maybe you can't afford not to get help. In the past, you could be just a photographer and survive nicely on whatever came in the door. That is no longer true. Now, you need to be a business owner and learn to delegate the work you don't have to do yourself.

Start with a job description. There are many tasks you can give to someone else to allow you the time and creative energy to work on self-assignments or other "business owner" responsibilities. As you go through your day, write down the tasks you could have delegated that did not require your personal attention. Do this for several weeks. Then, categorize the tasks into specific jobs in the areas of marketing, office management, and photography production. Here is a sample.

Marketing Tasks To Delegate

- Organize client/prospect database
- Research new leads/update database
- Organize materials for portfolios
- Prepare materials for cost proposals
- Manage direct mail/mailing house
- Inventory promo pieces/publicity/tear sheets
- Keep master calendar of ad design and production
- Respond to requests from ads/mailings
- Send/return traveling and drop off portfolios
- Write/mail press releases

Office Management

- Billing, bookkeeping, and filing
- Updating vendor files and samples
- Inventory and order office supplies
- Stock Photography filing and research
- Answer phones!

Photography Production

- Order and inventory film and supplies
- Research props and background supplies
- Test equipment on maintenance basis
- Test cases of film
- Shoot Polaroids of "test" models for jobs
- Organize and maintain location packing lists
- Prepare, pack and unpack location shoots
- Pickup and shopping for props and backgrounds
- Film processing to and from labs
- Janitorial/maintenance

Finding the right employee is critical to the success of working with a marketing coordinator. Remember, they are often the first encounter with current and potential clients. They will probably be logging cash disbursements and receipts. This is a really important and responsible position. You may experience hesitation and doubt, but overcoming your con-

cerns and concentrating on the search for the right individual will pay off in the long run.

Once you have a good idea of the job description and hours required, start looking! Here's a list of places to look:

- Local Colleges (Business Departments, of course!)
- Customer Service at Printers, Photo Labs (related businesses)
- Referrals from your associations (probably the best)
- The vast and highly qualified pool of early-retirees
- Share the marketing coordinator with your studio mates

For salary, you'll pay the going rate for office or administration personnel of six to ten dollars per hour. The greater the client contact, the more money and incentives you should create. In addition to a salary, high-level client contact can be compensated with salary plus commission. You'll find that you could hire someone for as little as fifteen to twenty hours a week at the beginning. Not only is this more affordable, but it is easier to find part time help among students or even retirees. Next, talk to your accountant about becoming an employer and the financial responsibility, taxes, and paperwork that will involve.

Interviewing Basics

This may be the first time you have interviewed and played the role of employer! Here are a few tips for conducting an interview. Your objective is to do the most careful job at an early stage to avoid potential disaster and heartache down the road.

Prepare in Advance

Be sure to use employment applications. Your local office supply store should have generic forms that you can customize. Call your local state office of labor relations and make sure that you get the information on state labor standards enforcement laws. Review the application and call and check the references. Ask "open ended" questions such as, "What are your career goals?" not "Do you have career goals?" The state labor office will also be able to help you with the legal considerations of equal opportunity employment and questions you can and cannot ask.

Explain the Written Job Description

Even though you have everything in writing, discussing the responsibilities will bring out any questions now (better than later). Remember, legally it is a lot easier to hire someone than to fire them!

Explain How You Will Make Your Decision

Let the applicants know if you will call them or send letters. Also, give a time frame so that they don't have to keep calling you for your decision.

Take Appropriate Notes

Again, you may have state laws regulating the hiring of employees that will affect the conversations and notes at the interview stage. Keep everything!

Employee Management

It will be very important from the start of your new relationship to communicate policies and practices and spell out the working relationship. Not only will this basic knowledge help your new employee to do his or her best work, it will make sure the work gets done in the most efficient manner. Put together your policies and practices "manual." It should include:

Mission Statement

Your mission statement and objectives as a business owner. For example, "My goal is to establish XYZ Photography as the premier portrait studio in my local market." Now, everyone at your firm is working towards the same goal!

Employment Policies

Employment policies such as work hours, overtime, performance reviews, vacation and holidays, sick leave, leaves of absence, injury on the job.

Benefits

Benefits such as health insurance, disability, worker's comp, additional training.

Employee Conduct

Employee conduct such as telephone and client handling, work space maintenance, reporting problems or concerns.

Motivating Your Employees

Sometimes, you can't compensate for work above and beyond the call of duty with financial rewards. There's no question that money is motivating. Here are some other ideas you can use. The value of recognition and attention can never be overestimated. The traditional object of recognition is some kind of "wooden applause"—a plaque, certificate, any inscribed gift.

Next, look at special training or conferences your employee might like to attend but that are not required for work. A better work environment is always an option, be sure to ask for their multiple choices of improvements they would like to see happen.

Finally, something as simple as unexpected time off is a wonderful motivation for an employee to work above and beyond the call!

Delegating Work You Could Do Faster

That's usually the factor that keeps employers from doing good delegating. They know they can do the work themselves better, quicker, faster. Yes, but at what price?

Here are the steps to follow in order to learn and practice the delegation skills you know will pay you back tenfold!

- Analyze the task at hand and write down all the steps. Sometimes, they are so automatic that you'll forget an important item making it difficult for your marketing coordinator to follow through and be successful. Not only is this lack of detail frustrating, it is very demoralizing!

- Decide what parts of the job you need to keep control over and what you can delegate.

- Plan the performance standards you will hold your employee to. No mind reading! Be sure to explain what your expectations are and what results you are looking for.

- Follow-up should be scheduled for a "reality check" to catch any mistakes or problems before they get out of control.

Computers and Your Photography Business

I t is no longer a question of should you have a computer for your photography business, but what kind? Completely aside from the issues of creating images on the computer, you must use computer programs in order to run your business most efficiently and effectively. It's no longer an option!

If you are (like so many of us) short on attention span and patience when it comes to learning what you need to know to make a smart computer purchase, hire a consultant. Not only can a consultant help you with the initial set up, but they will be able to hold your hand through the inevitable problems and glitches. Problems are a given. No matter the choice, MAC or PC, you are buying equipment that will make your life both heaven and hell. Don't expect anything different!

Get Professional Help

When seeking a consultant, look for someone industry specific. It is helpful if your consultant is (or was) a photographer and understands the business. However, it is not necessary and if you find someone you have a good chemistry with and who is willing to take panic phone calls at 2 A.M., go for it. At least make sure they have lots of experience with your choice of platform, MAC or PC, and plenty of background in small businesses that sell professional services—that's you! Try these tips:

- Interview as many as possible, remember short term pain (finding the time) will always bring long term gain (someone that will really work for you and stay around).

- Look for someone that knows "tech" but speaks "non-tech." Though you don't want to know what they know, you do want to know what they are doing to your computer and why.

- Network through your professional peer associations for referrals. Take advantage of someone else's consultant's learning curve.

- Try to work with "off the shelf" programs. Customizing software programs is very expensive and now that there are so many to choose from, there is one to fit your needs!

What You Need Computers For

There are five major areas of tasks a computer and software programs will perform for you:

- Business planning
- Marketing and selling
- Bookkeeping and accounting
- Photography production
- Digital imaging

Before you start looking for a computer, look at your business. For example, a studio shooter with lots of production-heavy assignments is more likely to benefit from specific inventory control programs for photographers than an editorial shooter that works on location. If you are completely on your own, a more expensive integrated program would be a time-saver. These are programs where your invoicing a client can be accessed in the client contact database. Individual software programs from different manufacturers for each of the above functions will not talk to each other!

Software and Hardware

Then, there is the hardware vs. software decision. Research and purchase the software first. The machine, the hardware, is just a piece of equipment. The software—individual or packaged—is the real brains behind the system. Never buy a computer with another manufacturer's software already installed. This is a marketing trick on the part of the hardware company to get you to buy their machine. Your problem will be that you're unlikely to get the technical support you can plan on needing from the software company—you didn't buy the program from them! The hardware company knows machines, not software! Also, make

sure the software you are evaluating is not a "twilight" program, that is, one that will be phased out of existence in the near future.

The biggest decision you'll make is whether to buy an integrated program (from $1,000 to $2,500) that will perform all of the above functions. The main advantage is that the information (say, from an invoice) is accessible from within other areas of the program (such as the client database). It's not a small thing to consider! Non-integrated software (from $75 to $250 each) are cheaper, but then you'll find yourself doing very time-consuming tasks such as retyping a client's name and address for each function or exiting one program just to find a client's fax number!

If you are considering adding digital imaging capability, you are probably going to have to purchase two computers. One will be dedicated to running and promoting your business. The second will be dedicated to providing digital services. Also, keep in mind that digital imaging requires tremendous RAM memory and storage capability, far exceeding what you will need for business purposes. Digital imaging tasks are also time consuming, and you can't afford to start and stop when normal business computing needs to be done.

One final point. Don't confuse digital imaging with digital capture. Digital imaging, covered later in this chapter, is done in the studio or office, and consists of things like color correction or alteration, retouching, photo compositing and the like. All of these are services you can market.

Digital capture, not covered in this book, is fixed or scanning array technology that replaces film. It requires either specialized backs, in the case of some large format cameras, or a new body, as in the Nikon system that approximates 35mm film. Digital storage devices are used in conjunction with these systems to store images. These images can be downloaded on dedicated desk top computer systems for manipulation or enhancement (digital imaging).

Business Planning

One important function to look for when buying software is the development of a business plan. Later (chapter 19) you'll find a specific marketing plan for a photography business. But marketing is only one aspect of a business plan. Look for a program that includes templates for spreadsheets, production planning, goal-setting, and the financial statements that are all critical aspects of business planning. This will be especially valuable should you need to approach a bank or financial institution for a loan or credit line.

Marketing and Selling

Here's where your software choice is the most critical and gets the most daily use and workout. A database program is imperative to organize and maintain client contact information. A word processing program that "mail merges" with the database and prints mailing labels allows you to send personal and custom letters for sales, quotes, and follow-up. These "contact management" programs assist with both client prospecting and maintenance by keeping track of names, people, addresses, contact dates, types of contacts, dates for the next contact. You should be able to easily search your database. For example, you want everyone that is a food client you talked with in May that said to call back in September. You should be able to sort the information as well. In the above example, a zip code sort allows you to talk to people in a geographic order. Then, when you make appointments, you are not driving from one end of town to another!

The days of the old shoe box and index cards are long gone for keeping track of information on clients and prospective clients. There are many different software programs, both for MAC and PC systems, available for contact management. Selecting the best one for you is not as easy as a word-of-mouth referral or what's on sale this week at the local software warehouse. Don't forget to consider whether to buy an integrated program (with other functions) or an independent one.

Some word processing programs even come with their own database programs. In addition, there are two basic directions to go with the database section of the contact management program. One, buy a program that has a pre-existing client profile form and fields of information. This is great if this is your first database and you can simply input the client profile information from your index cards into the existing fields. (A field of information is anything you want to retrieve later, such as addresses, phone numbers, or dates of client contacts). These take less time at the front end in the set-up, but are generally less flexible.

Two, buy a program that requires you to design the client profile form (sometimes called a "record") and specify both the fields and layout of the form. This takes more time at the front end in the start-up, but it will be exactly what you want. Either way, with any typical database form, your client profile will look something like the following example. A colon following a word creates a "field" and allows that information to be searched for, sorted, and retrieved.

alpha:_____
(allows alphabetical retrieval for firm names like John Smith & Company, at this field you would type "smith")

firm:_____

address:_____

city: _____ **state:**____ **zip:**_____

contact:_____

first name: _____

All above allow for printing mailing labels or merging with a word processing program for personal letters. You can also add fields such as those below.

addl: _____
(usually additional contact name, such as a secretary)

phone: _____
(always use area codes! great for sort and search)

fax: _____

date last: _____
(date of last contact)

type: _____
(type of contact—phone call? appointment?)

date next: _____
(date for next contact)

Keep in mind, the postal service requires the last line of a mailing label be the zip code, not the name of your contact!

The fields below are optional, but very useful for managing the information in your database.

type client: _____
(manufacturer? ad agency? magazine?)

product: _____
(usually a code, such as "f" for food clients)

project name: _____
(for follow-up and estimating purposes)

remarks: _____
(where lead came from, or any other comments!)

status: _____
(usually a code to distinguish current versus prospective clients)

Designing the form or record for the "client profile" is critically important for future follow-up. Selling your photography services can be simply thought of as managing the information on what clients and prospective clients need and when they need it!

For example, the profile above allows the following scenarios: You can call prospective clients, sorted by zip code, so when you're on the west coast, you are talking to the earlier time zones before lunch. You can call all current clients you talked to in January that said to call back when you had a new product promo piece. You can mail new promo pieces to just the prospective clients that saw your food photography portfolio. You can mail a different promo piece to magazines and corporations. All from one form!

In addition to the contact management function (which is not an option) you can look at the option of using desktop publishing software for the production of marketing materials. You can create newsletters, project announcements, copy for printed promotions, even brochures! Multimedia software programs can be used to create portfolio presentations that include video, graphics, and text with your images. Caution! If you are not inclined to take the time for the learning curve and constant software upgrades, continue your relationship with a graphic designer for your marketing materials. Let them buy the latest and greatest software and you still get the benefit of the new technology. Yes, it will cost you more but only if you don't count your time to learn and use desktop or multimedia software to your best advantage. Poorly produced materials will actually cost you more that hiring a professional designer.

Bookkeeping and Accounting

If a contact manager (database and word processor) seems like a marvelous advance in the business of photography, an accounting program will be like a miracle! Again, decide whether to buy into the integrated programs specifically designed for photography businesses or an *á la carte* program. Either way, what you will do is as simple as putting your business (and even personal)checkbooks on your computer. When you make a deposit or write a check, the screen looks exactly like a regular checkbook. In a computer program, this very same information without any additional data entry can be used for:

- Reconciling checkbook in about 1/5 the time—to the penny!

- Memorized transactions for the same payments every month
- Splitting payments into different expense categories
- Finding a transaction by keyword, check number, or date
- Net worth statements
- Profit and loss statements
- Transaction statements by category, payee or date
- Creating budgets
- Even ordering supplies

One caution, if you start at anytime but the beginning of your tax (or calendar) year, you'll have to enter all the checks and deposits up to that point in order to be able to use the reporting and searching functions effectively. Not only will the reports generated from this software help you make good business decisions, you will also save hours of time every week and month spent on managing your finances.

Photography Production

Finally, computer software can help you in the management of the production of photography assignments. Most of these are available as fully integrated software programs combining all of the above needed functions. They are expensive, but remember, the data entered once can be then used in any application. Look for these unique features when buying photography management software:

- Industry standard photography estimate forms
- The same for invoices
- Photography delivery memos
- Photo equipment inventory
- Stock photography management
- Cost analysis for photo jobs
- Supplies and props inventory
- Project management by job
- Calendar or time management

Digital Imaging

Many photographers have made the substantial financial investment required to buy a proprietary digital imaging system. Although I do not recommend it, other photographers have moved ahead with expanded hardware and software on their

current computer systems. Some take their work to another firm that will do the digital imaging for them! Which every way you choose, it's important to look at three questions: First, who are digital clients? Second, how do you sell your services to them? And finally, how do you determine what to charge for these specialized services.

Who Are Your Digital Imaging Clients?

For digital imaging, there are basically two approaches. One is to expand on the services you currently offer your existing clients. Image enhancement and additions, are two examples. "My photo studio clients are the same clients for my digital work," says Tim Forcade of Lawrence, Kansas. "My existing clients created a fee base to build on. I'm just using a different set of tools. I'm an artist, this ain't photography anymore."

Stan Sholik, a studio photographer in Santa Ana, California, adds another perspective. "My purpose in having digital capability is to attract better assignments. With a high-end computer system, there is no image that cannot be created. All that's needed is the photographer's visual sense to create a believable image and the client's budget to bring it about."

The second approach is to enter new job markets created by the digital technology, and seek out new clients. Some of these markets include multimedia production, book and magazine publishers, corporations with in-house image labs, companies that need interactive training programs, trade show presentations, entertainment and electronic games, educational programs, public facilities with interactive video kiosks, stock illustration and photography images, and, on-line services and publications.

According to Melody Michael, a rep in Santa Barbara, California, "The dramatic expansion of companies using digital work in film, television, commercials, and computer games, combined with the ability of an individual to do high resolution work in a home based office, allows you to go after new clients with bigger jobs and budgets... clients previously available only to larger suppliers. These clients prefer specialization in particular software, but I encourage them to look at the individual's skills and capabilities."

Marketing Digital Imaging

In reality, successfully marketing digital photography services requires the same thought process and promotion techniques that marketing traditional photography does. The new technology simply gives you more services to sell!

Portfolio presentations are still the most traditional method of selling any photography service, even digital. It's important to present who you are, what you can do, and how all of this relates to the prospective client during your presentation. Tim Forcade has this to say about selling new technology, "I'm always looking for new ways to form images and go after clients that have interesting and challenging projects. I look for clients most interested in combining new technology and traditional sensibilities, that are willing to constantly push to break into new mediums."

Be sure that your presentation leaves a very clear visual impression of the work. Showing everything you do will only confuse the buyer. Focus on a specific digital photography style and technique.

Don't forget to follow-up with everyone that sees your digital portfolio. If you don't have the time for a phone call, then drop a note in the mail. It's your job to keep in touch and turn people that see your presentations into clients.

Because advertising digital photography services is the most expensive approach, it should be carefully planned and well executed. The reason a client will look at your ad is because they are looking for capability they don't have. Your design objective is to give clients a strong and distinct impression of your capability, style, or technique and ask them to respond.

As with marketing conventional photography, be sure to tie into other marketing areas. For example, add people that respond from your ad to your mailing list. Another idea would be to add copy to your mailings to tie into your ads. For example, "See our ad in *New Media Showcase.*"

Getting published is the most inexpensive promotion for digital photography services. You can't buy it. You submit samples of your work with a press release and hope to get the information published. Unlike an ad you would place in publications clients might read, you should continually submit samples of your work and accompanying press releases to all media, client and non client.

Project press releases involving digital services (like the sample that follows) are very popular with the media.

Sample Digital Imaging Publicity

For Immediate Release For Information Contact
(use today's date) Maria Piscopo at
 (area code) phone number

DIGITAL IMAGING PUTS POPCORN COMPANY
IN THE SPACE AGE

SANTA ANA.... Sometimes assignments come in the back door. Stan Sholik, owner of Stan Sholik Photography, has recently completed an unexpected assignment to produce a digital image for the cover of the Popcorn Palace and Candy Emporium annual catalog.

A star-field background and simulated planet earth were generated entirely in the computer. They were then combined and shaded to match an original transparency of the popcorn kernels. Motion streaks were easily added and the image was outputted as a 4x5 inch transparency for reproduction.

The original assignment called for still life studio shots of the popcorn products and packaging. But when President, Bill Sanderson, saw Sholik's photo-composites on display in the studio, he was immediately intrigued. "I inquired about doing a space age shot," commented Sanderson, "following up on the current interest in the twenty-fifth anniversary of man's moon landing and, the activity involving the planet Jupiter. Sholik's image of our popcorn kernels flying through space over the earth not only replaced our traditional cover photo, but became a fabulous marketing theme, 'Popping the World—one kernel at a time.' It reflects both our unique custom manufacturing process and our desire to stand out among the competition."

Stan Sholik specializes in combining food and product photography with digital imaging and is represented by Maria Piscopo.

###

The word of mouth benefit from getting published outweighs the fact that the publication isn't targeted to your particular clients. Then, you can reprint any publicity, and mail it to the clients on your own mailing list!

Mailings are another form of marketing very popular with digital photography services and buyers of these services. When you can clearly identify your client base, i.e. editorial or entertainment clients, mailing labels and lists can be purchased from industry sources such as Creative Access in Chicago.

A regular schedule of mailings to the people on your list is very important when you are adding new technology services toyour business. Clients need to get between six and sixteen visual impressions of your digital photography services before they will recognize what this new technology can do for them!

Glen Mitsui of Seattle, Washington, offers this insight, "My most successful promotion has been to research publications that use cutting edge editorial illustration and corporations outside the computer industry that show strong conceptual thinking in their promotions. I then send a series of letters followed by phone calls to make arrangements to show my portfolio. By the way, when my portfolio on disc was not so successful, I went back to using slides and found that content is everything. Pretty pictures just don't do it."

Determining What To Charge For Digital Services

As a photographer offering digital imaging services, you have two conflicting needs. One is to give your clients what they want, at the price they want. The second is to get the work you want, cover all expenses, and make a profit.

It's very important to position the work you're doing as a creative service and not a product. "When we first began representing Mark Jasin," says Martha Spelman, a rep from Los Angeles, "we found that we could get slightly higher fees because he had a much larger investment in equipment than our clients. However, with the upgrading of equipment by clients, we now find that fees are approximately the same as we get for photographers working conventionally. Most often, a higher fee could be considered a by-product of the job and the photographer's reputation or individual 'niche' style. In other words, these digital photographers would be getting higher fees because their work is in demand, or more complex than conventional photo techniques allow."

J.W. Burkey of Dallas, Texas, offers this additional comment: "There is one important way that digital imaging is different from traditional work. I call this, 'the paint is never dry.' In digital imaging, clients want to make changes the next day, the day after that, and a week later. These changes can easily take as much time as the original work, and this is the easiest way to lose money with your computer.

"Fortunately, there is an answer. Smart reps have traditionally dealt with this by putting into the original estimate and assignment confirmation exactly what the price includes. Typically, the quoted price will include one rough, one finished print or transparency, and one round of minor revisions. Art directors and graphic designers are used to this.

"Adapted to digital imaging, the first step would equate to one low "rez" rough, say seventy-two pixels per inch with no clean-up. The second step would be a full resolution image with all but the final clean-up. The minor changes would include repositioning or resizing a scanned in element. Or, it could be a color shift.

"Here's my rule of thumb: If the client could see it in the rough and didn't make the change, it's billable. Breaking even is not the idea. You are taking a risk when you invest in new equipment and spend months learning to use it. That risk should be rewarded with profit.

"Many of the practitioners I know charge by the hour. I don't like this because it makes us into plumbers. I like to quote a fee for the project. After a few jobs, you quickly learn to charge more. It always takes longer than you think it will. Clients are used to paying anywhere from one hundred fifty to six hundred dollars an hour for technicians at a color separator. Should a photographer charge more or less than a technician? Obviously more.

"But don't just start, when estimating jobs, figuring that anything is better than nothing. At the very least, know what is the least you need to pay all your expenses and take home a decent salary. Know your bottom line."

Tim Forcade adds, "Work in stages in terms of pricing. And don't give your work away. Find out what you can do, and bill out at a fair market rate. If you don't, you will forever be pegged at your give away price."

Calculating Digital Imaging Expenses

Keep in mind that a photographer that does not do digital capture will need to have transparencies or reflective art scanned and put on disc at a service bureau, prior to his doing retouching, photo composition, etc. at his facility. And don't forget, in most cases, that same service bureau will have to output your work back to either transparencies or film.

So, how much do service bureaus charge? Here are some thoughts from Sam Merrell of New York on determining these "outside vendor" digital imaging expenses that must be passed along to your clients. "Photo CD scanning prices have gone up

(on average about twenty percent). About the lowest prices I've seen quoted are in the fifty-nine cent range—and this number assumes a quantity job, uncut rolls of film, perhaps bundling film development and printing in with the scans.

"Photo CD Professional Master scans are now available... a new, low cost option for higher resolution scanning (from 35mm, 2 1/4, and 4x5). Usually, service bureaus are charging anywhere from twenty to thirty dollars per Pro-PIW scan. From what I can tell at this point, there are still a lot more drum scanners out there than Pro-PCD imaging workstations.

"There are now several low end desktop drum scanners on the market (in the area of twenty thousand dollars), and I've seen quotes for low-end drum scans in the fifty dollar range. One or two of my clients know that they're going to be needing over two hundred scans a year, so they go to a service bureau that will cut them a volume deal.

"I have one client who has no creative fee, but is billing a flat three hundred and fifty dollars for system access, plus two hourly rates. One rate is for lead creative. The second is a lower fee for the technician."

If you are considering adding digital imaging to the other creative services your photography business offers, please keep this in mind. The computer is just a tool. Like cameras, airbrushes, and other tools of expression, computers do not generate work or add profit by themselves. It takes a skilled creative professional trained in the technical requirements of software and hardware to produce high quality results.

No matter what your level of experience, you can combine a new look at your internal business structure and equipment with a review of your current marketing strategy, and then decide how you can make a greater profit with computers. They will save you countless hours of office work. They can make your marketing presentations look more professional. And, if you add digital imaging to the services you offer, computers can increase your level of project involvement and control. One word of caution. Computerizing your business, particularly if digital imaging services are involved, requires a considerable investment in hardware, software, and training. Whenever possible, seek advice from other photographers in your field of specialization and consider hiring a consultant to help you configure your system.

Getting Started in Business

When you are just starting out, it is important to set priorities for business, marketing, and self-promotion. It is essential to work with a checklist that will help you plan for your start-up budget.

Where do you start? What are your legal, financial, and tax responsibilities? How do you budget for a start-up? How do you write a business plan? If you are asking these questions, this chapter is written for you!

Starting Your Business Checklist

Forms of Business

The place to start is to decide on the form your business will take. Even a part-time business has to have some kind of structure. There are three forms to choose from: corporations, partnerships, and sole-proprietorships. Corporations no longer have the many advantages they used to. The primary reason for incorporating a business that is starting out, is for protection of your personal assets against any liability. However, you are unlikely to be in a situation that makes you as vulnerable as, say a doctor, who has a much higher level of personal liability. Check with your personal accountant for the best time to incorporate for any tax advantages.

Partnerships are not unusual in photography but you must have a partnership agreement. Even if you have known

the other person since childhood, differences and dissension will potentially have tremendous financial impact. Don't leave home without one! The primary reason you really need a partnership agreement is for the termination of the partnership—something no one thinks about at the beginning of a relationship. But the worst time to negotiate terms of a dissolution is at the time you are splitting up. Partnership agreements are fairly standard legal contracts, so don't hesitate to investigate the cost of a consultation. The most successful partnerships seem to be a meeting of two minds—one business and one creative. One partner handles the photo assignments and the other runs the business.

Sole proprietorships are the most common form of photo business. They are by far the easiest and least expensive to start and run. The down side is that you alone bear the total financial liability. The good news is that all the profits are yours.

Business or Hobby

You will want to make sure that your photography business is set up to be a valid business. The Internal Revenue Service has uncovered many abuses of the "hobby loss rules." Some people with a lot of expensive camera equipment will try to declare the equipment and expenses as a business when they are really hobbyists. This, of course, lowers their tax liability and causes the IRS great worry! Again, check with your accountant, but the main factors the IRS will consider are the separation of business and personal money, the efforts to market your services and other sources of income. Being audited and declared a hobbyist will cause the loss of your business deductions. Since this will raise your income tax liability, you should be highly motivated to maintain all the appearances of a real business.

Business Checking Account

This is the most important evidence of your seriousness as a business and essential for the accurate estimating of your income tax liability. Your "Schedule C" on your Form 1040 Income Tax Return will be calculated out of your business checking account. Paying business expenses out of your personal checking will cause an artificially higher net profit, and higher income taxes for you to pay!

Bookkeeping Journals

Good records are an essential part of starting a business and an important piece of evidence to the Internal Revenue Service

that you are serious about your business. The most basic records are Cash Receipts Journal (money in) and Cash Disbursements Journal (money out). Always check with your accountant before deciding on the best bookkeeping system for you to use. Since they will be calculating your tax liability from these records, you want to be sure to use a system they are familiar with—or you will pay much more for your tax return.

List of Assets

No matter when you purchased your car, computer, or photographic equipment, you can bring these "non-consumable" assets into your business and depreciate their cost as a form of deduction against your tax liability.

Legal Requirements

Business License

When you live in an incorporated city, they will require you to obtain a business license, most often renewed annually. Some cities also require a one-time permit for a home-based business. This license is issued at your local city hall. Since every city is different, first determine what is involved for fees and evidence of residency. For photography businesses, city business license offices are sensitive on two points. One, will your new business generate lots of foot traffic or need exterior signs? You may live in an area not zoned for these factors. Second, will your new business generate toxic wastes? Environmental issues dictate concerns over such things as darkrooms and chemical processing.

Fictitious Name

A D.B.A.(Doing Business As) permit is issued by your county when your surname is not used in your firm name, such as "Mary's Photography." Caution! You will have to take this step first if you plan a fictitious name because most banks will not let you open a business checking account without the D.B.A. You can go the county building or use the filing services of your community newspaper.

Resale Number

When you start a business in a state that charges sales tax, no matter how small the business, you need to charge, collect, and pay the appropriate state sales tax on your entire invoice. Contact the State Board of Equalization office closest to you for their

publication on the rules and regulations in your state. For a low volume of sales, you will file and pay yearly. Most businesses file and pay quarterly. Remember, when you get paid for a photography job, the sales tax is not your money. Find a way to set the amount aside on a regular basis so that payment is not such a shock.

The State Board office will issue you a resale number in order to keep track of your payment of the taxes you collect. In addition, you can use this resale number and not pay sales tax on items you purchase that will physically transfer ownership to your client. For example, you can use your resale number when purchasing photographic paper, but can't use it when buying equipment. Again, check with your State Board publication for the latest information.

Federal Identification Number

For the sole-proprietor, this is your social security number. If you become an employer or another form of business, you will need to apply for a separate identification number from the Federal office.

Business Insurance

The moment you start your business, whatever homeowner's insurance you had on your photographic equipment (as a hobbyist) is no longer applicable. You will need a separate business insurance policy for equipment loss or damage as well as business liability insurance.

Budgeting For a Start Up Office

Phone and Fax

A business phone number and fax machine are essential to doing business today. One line can serve, but be sure you don't answer the fax phone number.

Answering Machine

Consider a phone answering machine with a remote operation feature. Be sure to check on the remote feature. Some manufacturers only work from phones that have very long pulse tones and you will not be able to pick up your messages from most locations! Machines can process more information than an answering service and are more cost effective. In today's voice mail environment, you shouldn't have any problem using an answering machine or voice mail.

Computer

A computer for the management and marketing you must do is required and no longer a luxury for running your photography business. Computers and your photography business are explored in much greater detail in chapter 17.

Marketing Materials

One of the hidden costs of starting a photography business is all the marketing materials such as portfolios, promotions, buying sourcebook directories and paying organization dues. You may want to write your marketing plan before committing to a final start-up budget!

Improvements

Plan ahead on any expense involved in office, darkroom, or studio improvements. Even if the addition or expansion is not immediate, better to plan for the money when you can get it! Don't forget about a car and studio security system. It can lower your insurance costs and save tens of thousands of replacement dollars in the event of loss or damage to property.

Writing a Business Plan

A written business plan is an essential part of the marketing, management and financial planning of a business. Goals are dreams unless there is a plan of action. Nothing ever really gets done unless it is written down.

The business plan is done in four parts and may be done in outline or paragraph style. The plan must be typed and the length is usually from one to three typed pages. The exercise is worth the effort and important to do at the beginning.

A plan will give your new business focus and direction, and will help you to identify the marketing you will later plan for (see chapter 19 for writing a marketing plan). There are dozens of formats for writing a business plan. Check with your local Small Business Administration office for their publications on the subject. Another option is to make an appointment with a SCORE consultant, a division of the SBA. SCORE (Service Corps of Retired Executives) offers free business consultations on any subject—including writing a business plan!

Business Plan Outline

1. **Statement of Purpose**

 What do you do and who buys it?

 As a photographer, I provide manufacturers with the use of photos of their products for ads and catalogs.

2. **External Evaluation**

 These are aspects of business you cannot control such as your length of time in business, economy, competition, weather, etc. A careful analysis here helps you determine your chances of business success.

3. **Internal Evaluation**

 These are aspects of business you can control such as your business skills and knowledge, copyright information, start-up budget, bookkeeping software, technical skills, equipment needed, etc. They should be outside of your marketing efforts, such as portfolio and promotion, as you will be planning for those items when you write your marketing plan (chapter 20). Take your time with this step. These are all factors you have the power to take charge of and change for the better.

4. **Setting Objectives and Tactics**

 What tasks must be accomplished to strengthen the areas listed in number 3? Be very specific and list or state exactly what you will do and by when.

.
.
.
.
.
.
.
.

Your Personal Marketing Strategy

.
.
.
.
.
.
.

By now it should be obvious that self-promotion is as important to a successful photography business as your equipment or education. It's important to master the keys needed for successful promotion and to write your own marketing plan.

Keys To Success

Planning ahead plays a big part in the ongoing success of your photography business. In this book, we have discussed planning successful advertising and direct mail, planning publicity and portfolio presentations, and writing a marketing plan. Now we will look at how to do all this time-consuming work! In order to "have it all" you need to learn three keys to success: referral networks, self-assignments, and scheduling techniques.

Referral Networks

If you don't have a referral network, get yours going right away. A referral network is a group of people you can count on to refer work to you. They could be other photographers whose work complements yours. They are often good clients who act as advocates and are willing to tell their friends about you and your work. They could even be people in the community that don't buy from you, but can influence the people that do. In order to maximize the number of referrals you get from people

like these, you need to set up an official referral network. In order to develop and maintain your referral network, please read the checklist that follows.

Referral Checklist

❏ Set up a mailing list of all of the people that have referred work to you. A photographer in business for more than three years should be able to identify at least six to twelve people who refer to them. Even if they have only done it once or twice, add them to the list to see if you can increase the number of referrals. The more the better!

You probably already have these individuals on a mailing list of clients and prospective clients. You probably keep this mailing list in a manual "label" style (available in most office supply stores), or in a database software program in your computer. This referral mailing list is in addition to any other mailing or promotion you will do and should be hand-addressed to distinguish it from yourregulardirect mail.

Most often, your best source of referrals are your own clients. They should get all the same promotional materials any other potential clients get, plus this extra attention. At least six times per year, send them some kind of personal promo piece designed to "keep in touch." It could be a postcard from an out-of-town trip. It could be a personal letter. It could feature your photography and be more of a greeting card then a hard-sell piece. It should have some kind of hand-written note to let this person know you took the time and care to send this to them. They may also be on your computer or regular mailing list, but you recognize that they are something special to you. The more personal, the better!

❏ Many times when we get a call for an assignment, we are so thrilled to get a job we forget to ask where it came from! Redesign and reprint the estimate form you use to gather information for a job to include the space to write the answer to the question, "Who referred you?" Get all the information you can about how this job came to your door and about the person that made that happen for you. You want them to do it again! Add this person to your referral network mailing list if they are not already on it.

❏ Immediately send a thank you note to the person that referred to you—don't wait to find out whether you got

the job or not, just do it! This is not the kind of chore to put off or to schedule for another day. To make sure it becomes a habit and to make it easy, keep correspondence materials available. Design, produce, and print a set of note cards featuring your photography, now, so they'll be handy to send. Keep a stack by your phone, so that you can address and mail them as soon as you receive a referral.

❏ If you have been putting off joining your professional association, mail your application today. If you let your membership lapse, renew it immediately. If you are a member and haven't been to a meeting recently, go to the next one. People hire people that are "known" and you have to make that happen.

To identify the appropriate association, you have several sources. First, the reference section of your local library keeps a copy of the *Encyclopedia of Associations* and the local Chamber of Commerce Directory. Advertising industry associations have been listed in creative source books, such as, the *Workbook*, and the *Adweek Agency Directory*. Be sure to attend photography industry trade shows. You'll be able to meet various association personnel at their booths in the exhibit area.

Remember. In today's competitive environment, you need all the help you can get. People only refer to people they know and work with and your professional association is the place to make that happen!

Self-Assignments

In your marketing plan, you will target types of clients and/or assignments in areas you want to get more work. Unfortunately, you can't wait for someone to give you the work you want to do. So in order to get samples for your portfolio so you can sell in these new areas, you must use self-assignments. A successful marketing strategy should never depend solely on the work you have been hired to do for clients because it will not reflect the work you want to do. Take the time now to schedule a series of self-assignments that will represent the work you want to do more of.

By creating, budgeting, and scheduling these projects, two things will happen in your photography business that will help "even out" the ups and downs. First, the work of self-promotion will get done in the course of your day-to-day work. Second, you'll always have an assignment! You'll never have a blank calendar staring you in the face. Self-assignments are the

key to getting the work of self-promotion done. And, if schedule them during your normal work week, you'll be able to stay motivated and get the work done.

Sit down and plan your self-assignments for the next three months now. Make sure you have a "planning meeting" quarterly. This will keep your portfolio up to date and in reality, will let you be your own best client!

Scheduling

The real key to working any plan for business and self-promotion is to make these "non-creative" tasks a natural element of your day, rather than something to do when there is nothing else to do!

After you have written your marketing plan, transfer every self-promotion chore onto your daily planner. Schedule every self-assignment as though it were a job for a client. Give every phase of your strategy a day and a time to work on it.

Be sure and break your plan down into manageable pieces that can be easily scheduled into your work day. For example, rather than scheduling "produce portfolio for digital photography," you would divide it up into "create concepts," "research portfolio formats," "get digital prints made."

Schedule Time Off

Don't forget to schedule time off to recharge your batteries, trips to conferences, and the trade shows I mentioned earlier. With a framework and structure to your daily, weekly, and even monthly calendar, you will have accomplished two important things. One, you'll have a much better and more efficient scheduling of incoming work. Two, you'll always be busy with projects and activities. You'll stay happy, creative, and motivated. Clients will notice this in everything from your voice when you answer the phone to the quality and frequency of your contact with them.

This will actually encourage clients to call you with their jobs. As everyone knows, "When you want something done, give it to a busy person!" When a paying job comes along, you can always reschedule the self-assignment, or that day off you planned. But, if it is not there on your calendar staring back at you, you will probably never get around to it at all. The problem with not scheduling is that you'll do the work that's in front of you (not necessarily the most important work), and it will expand to fit the time you have. The reverse is also true. Given a framework or schedule to keep you on track, project

time shrinks based on what you surround it with. You can't decide how and when to fit paying jobs into a structure that isn't there.

Writing Your Own Plan

Now you're ready to write your own marketing plan to promote and sell your photography services. Please refer to the sample marketing plan given here as you write your own. Because this is a sample, the plan uses only some of the ideas for self-promotion presented in this book. Before you begin, be sure and thoroughly review the chapters on advertising, direct mail, public relations, and personal selling, and make sure you understand all of the material. Since the money spent on marketing is always a percentage of projected gross sales, be aware that if you've been in business a number of years, it would mean a bigger promotion budget than if you were just starting out. The amount of previous marketing experience you have will cause each plan to be different. Each individual is unique. Even when two photographers offer the same service, they won't have the same marketing plan. Each will bring his own particular resources and energies into it.

The purpose of the written plan is to outline a twelve-month strategy for each of the four marketing areas: advertising, direct mail, public relations, and personal selling. Though you can write in paragraph form, the outline format is recommended for several reasons. It is much easier to read and review, it is easier to add to and update throughout the year, and it is less work to write!

There are two important aspects of any plan. One is that you break down every task into small enough pieces. Then, take these "bite-sized" tasks and cross reference them to your daily planner. The key is to plan the work and work the plan, and this is also your key to success.

In an interview with corporate photographer, Lauren Brill, she emphasizes the importance and feasibility of writing your marketing plan, "Writing a plan is not as hard as one might think. After you understand what it is, then addressing your target audience is the easy part! Most businesses have some kind of plan. Some are a simple sketch of what they are doing, some have a hard-and-fast plan.

"A plan is not just your advertising, but your overall game plan for identity, customer service, portfolios, advertising--everything! If you look at how big corporations break down their marketing you will see a pattern. For example, Starbucks Coffee is one of the newest Fortune 500 companies and they are

great when it comes to marketing. They know that marketing is perception and perception is marketing. They know the market they are after and then gear their stores and products for the way that market perceives them. To bring this home, if you look at photographers making a good living, you will find that most of them have some type of plan of attack. You'll also find that a key is breaking down the elements of marketing. No one gets from A to Z without breaking down the elements. That's all marketing is!"

Points To Consider Before Writing Your Plan

You have many options to consider before writing your personal marketing plan. Think about the kind of photography work you want to do more of. This will help you write section one of your plan (what we are selling). As you will see in the sample marketing plan, you need to create as much detailed information about your marketing message as you can.

The amount of detail you create in section one provides specific information on finding clients you will need in section two (who we are selling to). For example, if you target location photography, as in the sample below, that dictates that you will work for companies that routinely use location photography.

In section three (how to get the work) you will take each of the four marketing tools and decide how and when you will apply them. The application of these tools depends on your own resources and goals. Background information for applying these tools is discussed in chapters 2, 3, 5, and 9.

Finally, be sure to highlight action items and schedule them on your daily planner. The best marketing plan won't work if you don't implement the tasks or "action" items in section three.

Sample Marketing Plan

What We Are Selling

A. First, write your marketing message in order to turn it into a concept for promotions.
 1. "The Photography of Locations"
 a. Creating images of a location, setting, surroundings, places, buildings, environments
 2. Broad subject and industry coverage:
 a. Ranging from travel, hotel, architectural, resort, leisure, transportation

Action:　Meet with art director and copywriter to discuss

Who We Are Selling To

A. Design Firms for high-end (Fortune 1000) companies
B. Ad Agencies for ad campaigns from clients in:
 Aerospace, Airline/Travel, Agriculture, Computers, Environmental, Healthcare, Telecommunications

How To Get The Work

A. Direct Mail Campaign (reach both markets)
 1. Need designer to create concept, photography, and production of campaign
 a. Mailed every six weeks
 b. Self-mailer with response card
 c. Make a strong offer for response
 d. Preferably single strong image
 e. Objective is to "cull" bought list by getting responses to create personal database
 f. Design mail to double as promo piece insert in Capabilities Brochure
 2. Need mailing lists that match above profile

 Action: Find designer/copywriter team and research mailing lists

B. Advertising Campaign
 1. Objective is to impress audience with marketing message and ask for response to send more information and add to personal database

 Action: Call annual source books for current media kit

C. Public Relations Campaign
 1. Should reach both advertising and design clients as well as photo peers (for referrals)
 2. Plan quarterly project press releases to all media
 3. Umbrella concept—all press releases come under above marketing message
 4. Start entering all awards programs with both self-assignment and published work
 5. Submit self-assignments to industry publications like *Communication Arts*

 Action: Build database of all media/editors of photography and advertising industry pubs and all awards programs, schedule press releases, review existing images for awards and publication submission.

D. Personal Selling

 1. Concentrate quality time on the "Best Bets" for commercial assignments and plan monthly or bi-monthly calls for follow-up

 a. Past commercial clients

 b. Past prospects for commercial work

 c. Responses to direct mail (and ads)

 d. Leads from editorial assignments

 e. Leads from above mailing list

 2. Portfolio

 a. Continue with laminated transparency in 8x10 outside size

 b. Need three duplicates of each portfolio for traveling

 c. For advertising portfolio, create multi-industry body of work that a subject-specific portfolio can be pulled from, based on client of ad agency

 d. Order traveling cases

 3. Promotion Material

 a. Order gray folder with logo

 b. Add ad reprints and laser color copies of tear sheets along with existing PR reprints/bio

 c. Use as a "capabilities brochure" sent upon request for more information until budget is developed for separate eight page brochure

Action: Build personal database and re-organize portfolio and promo materials.

Now It's Your Turn

Some of the more important points we have covered in this book include:

- Self-promotion doesn't come naturally to anyone. It's a valuable skill to learn.

- The only guarantee in promotion is if you don't do it, you won't be as successful as you could be.

- You must have a written plan with goals that include specific tasks and completion dates.

- All your promotional tools must work together. They need a memorable design sense to convey your image as a photographer, and they must communicate your marketing message of "here's what I do."

- For maximum effectiveness, any advertising or direct mail must be done as a campaign, not as a one-time effort.

- Public relations may not be a direct source of jobs, but it does increase the effectiveness of your overall self-promotion and builds word-of-mouth referrals.

- Before planning any extensive self-promotion campaign, know what you do and who buys your kind of work. This will allow you to direct your promotion to the correct market.

- Learning to sell yourself is as important as learning photography. Selling is no more complicated than identifying the photo buyer's needs and finding out how you can fill those needs.

- Communication skills are particularly important because people who buy photography need to feel secure that they will get the end results they need. Inform them and reassure them.

- Pricing is an important part of selling your photography and should be treated as another form of promotion.

Starting a new business, or making an existing business grow, takes both knowledge and time. I've given you all of the knowledge you need in this book. Now it's your turn. Get out your daily planner and schedule time to write your own marketing plan. Use the outline presented above as a guide. Review the chapters on advertising and self promotion as needed. Build your own referral network. Schedule the self-assignments you'll need to create a portfolio that will truly be an effective sales tool.

Start today. In less time than you think, you'll have your marketing plan written and action items scheduled. And for once, you'll be in charge of your work, rather than having your work be in charge of you. Stay busy. Stick to your plan. In time, your business will grow, your goals will be met, and you will be the success you want to be. You deserve it!

Glossary

Advance: Payment made prior to out-of-pocket expenses, such as travel. Most common when estimated expenses exceed fifty percent of the photo fee.

Advertising: Using non-personal techniques, such as directory listings, to reach a large number of prospective clients.

Agency: Advertising or public relations firms that acquire photography for client companies.

Assignment confirmation: Written estimate or bid outlining terms and conditions, that is signed and returned by a photographer's client to confirm a job.

Art buyer or art coordinator: The person in a large agency or firm who is responsible for negotiating photography purchases.

Bid: Stating definite fees and expenses based on specific information supplied by the photography buyer.

Book: Another word for portfolio.

Buyer: A client or prospect who has the authority and budget to purchase photography services.

Client: A photography buyer who is currently on a photographer's list of active accounts.

Client base: People from whom you get work on a repeat basis.

Client direct: Working directly with a corporation or company interested in buying photography, rather than through an agency.

Client publication: A magazine or specialty newspaper read by photographers' clients.

Comp or comprehensive: A sketch or layout of a concept for which a buyer needs photography. It is presented to the photographer in order to get a photo bid or estimate.

Commissions: The percentage of photography fees paid to a representative, usually twenty five to thirty five percent.

Consumer advertising: Buying ad space in publications distributed to the general public.

Consumer magazines: General interest publications subscribed to by the general public.

Contract: A legal document or agreement describing the terms of a working relationship between two or more parties. The agreement should be in written form.

Copy: Words used in an ad or promotional piece to inform the reader, explain images, and clarify the marketing message.

Copyright: The legal right to reproduce or sell a creative work. The holder of a copyright may sell that copyright, allow buyers to purchase various usage rights, or sell the original work.

Cost per contact: Total cost of promotion divided by the number of people the promotion reaches.

Day rate: Fee guaranteed to the photographer against the resulting usage. For example, in editorial work the photographer could receive a three hundred dollar day rate plus an additional amount of six hundred dollars for full page usage of a photo.

Demographics: Characteristics of a group of people to whom you are selling, such as their job title or zip code.

Deposit: An advance payment of part of the estimated fee for a job.

Digital capture: Capture and storage of an image by electronic means. Replaces film and requires special cameras or film backs.

Digital imaging: Manipulation of a new or existing image by electronic means. Some examples include electronic retouching, color alteration, making composites, etc. Images that were not captured digitally originally, must be scanned, prior to manipulation.

End user: The company that makes final use of a photograph. For example, an ad agency resells the use of a photograph to a client for an ad. That client is the end user.

Estimate: A statement of approximate fees and expenses based on preliminary information supplied by the buyer.

Expenses: Direct job costs billed to the client that resulted from producing a photography assignment.

Fees: Pricing determined by the usage rights purchased, amount of time spent, and the complexity of a job. Experience, reputation, and quality of the photographer's facilities are also factors used in determining fees.

First North American serial rights: First one-time usage of photo rights for magazine (serial) publication.

Graphic designer: A client or prospect who buys photography for corporate communications ads, brochures, or annual reports.

High end: Jobs or clients that give a photographer the highest level or prestige and/or money.

House accounts: Photographer's clients whose fees are not shared with the representative.

House organ: A publication produced primarily for a firm's employees.

In-house: Purchase of photography made by an employee of a firm rather than an outside agency.

In-house rep: A photographer's employee who has marketing responsibilities and does not rep other photographers.

Invoice: A bill of sale with information on payment terms, usage, and copyright arrangements agreed upon by photographer and client.

Marketing: Selling goods or services through advertising, public relations, and personal selling.

Media kit: Promotional information used by a publication to sell advertising space.

Overhead: Fixed expenses of a business such as rent, utilities, and salaries.

Page rate: A photography fee based on the amount of space used for a photograph in a publication such as a magazine or newspaper.

Periodical or publication: A newspaper, magazine, newsletter, brochure or printed piece.

Personal selling: A part of marketing that involves personal presentations to buyers, generally with a portfolio or by phone.

Promo or promo piece: Printed material, such as a brochure or postcard, used for promotion.

Proposal: A package including the bid or estimate with marketing materials, such as a cover letter or photo samples.

Prospect: A buyer with good potential for becoming a client.

Public relations: A marketing technique which involves non-personal communication with the public, through the media, as well as networking.

Purchase order or P.O.: Written authorization for a buyer to purchase goods or services from a photographer.

Rate card: A printed piece distributed by publications to

inform prospective advertisers of current advertising rates, frequency, and material requirements.

Representative: A photographer's marketing agent.

Royalty: A payment made to a photographer based on a percentage of the sales receipts of products using a photograph taken by the photographer.

Shopper: A community ad paper, usually offered free to readers, which can be a medium for advertising photo services.

Specialty line: Additional wording in a directory listing, indicating photo specialties.

Stock photo: Usage of existing photographs that are re-sold by the photographer or a stock photo agency.

Stock photo agency: A marketing firm for photographer's stock photo images.

Tear sheet: A sample of a photographer's work taken out of the actual publication in which it was published.

Trade advertising: Buying ad space in directories and publications within a specific industry or field (trade).

Trademark: Names, logos, or mottos that manufacturers use to identify their products.

Trade magazines: Limited and/or controlled circulation publications subscribed to by small, targeted markets— usually specific industries.

Trade out: Exchange of services for services.

Usage: Specific rights transferred to client defining who, how, where, and when a photo will be used.

Work for hire: An exemption in the 1978 Federal copyright law which gives the client the copyright of a freelance photographer. There are two kinds of work-for-hire: that done as a regular employee of a company, and commissioned freelance work in which the photographer signs a written agreement relinquishing all rights to the work done.

Index